IBOU NDOYE

FORMS OF FACES

New Drawing

February 2012

Victory Hall Press

Editor: James Pustorino

ISBN-13: 978-0615592985 (Victory Hall Press)
ISBN-10: 0615592988

Copyright © 2012 by Victory Hall Press

website: www.victoryhallpress.org

contact: victoryhall1@msn.com

Victory Hall Inc. 74 W46 St
Bayonne, NJ 07002
www.victoryhall.org

This program is made possible in part by funds from the New Jersey State Council on theArts/Department of State, a partner agency of the National Endowment for the Arts, administered by the Hudson County Office of Cultural and Heritage Affairs, Thomas A. Degise, County Executive, and the Board of Chosen Freeholders.

IBOU NDOYE

FORMS OF FACES

NEW DRAWING
VICTORY HALL PRESS

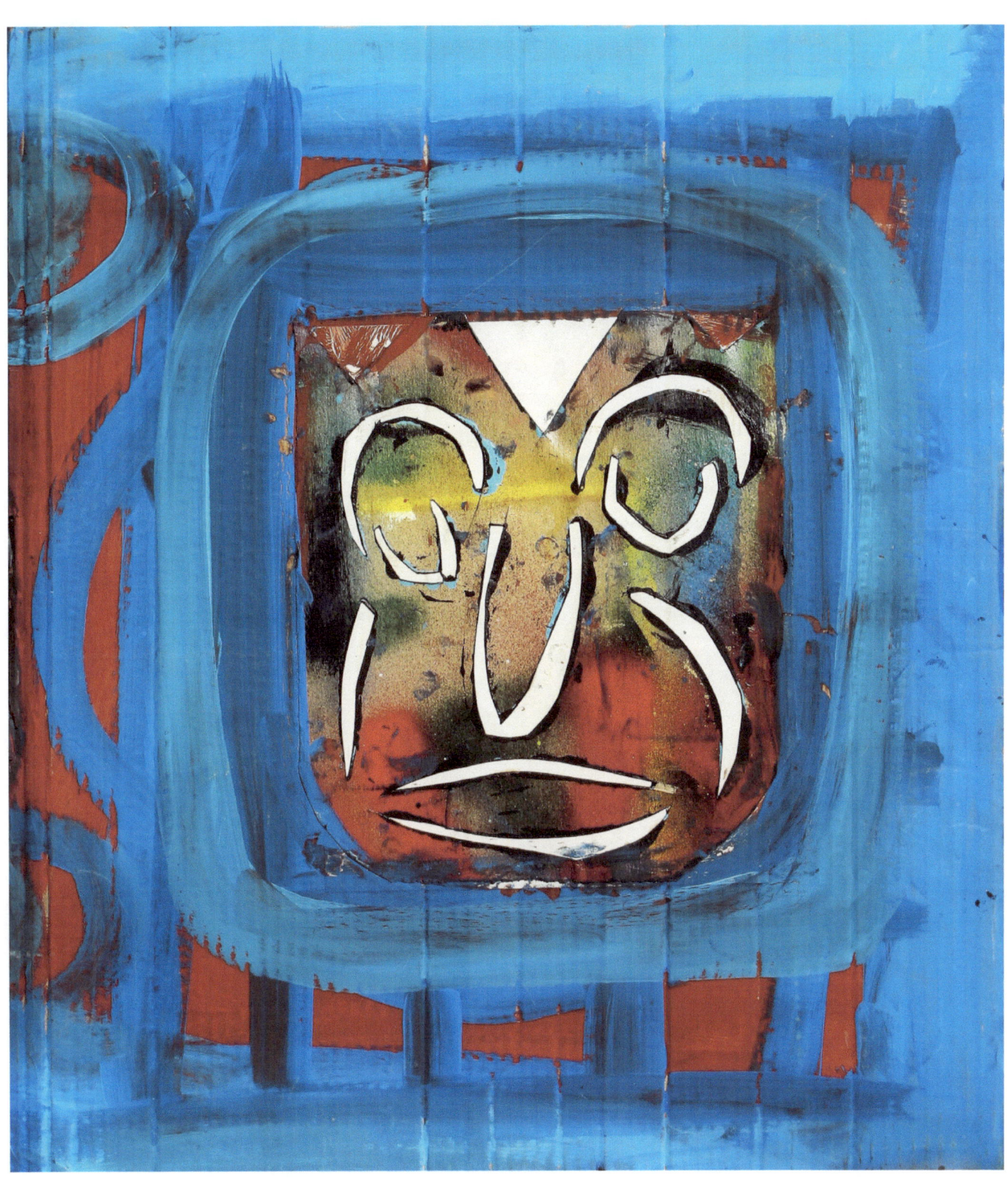

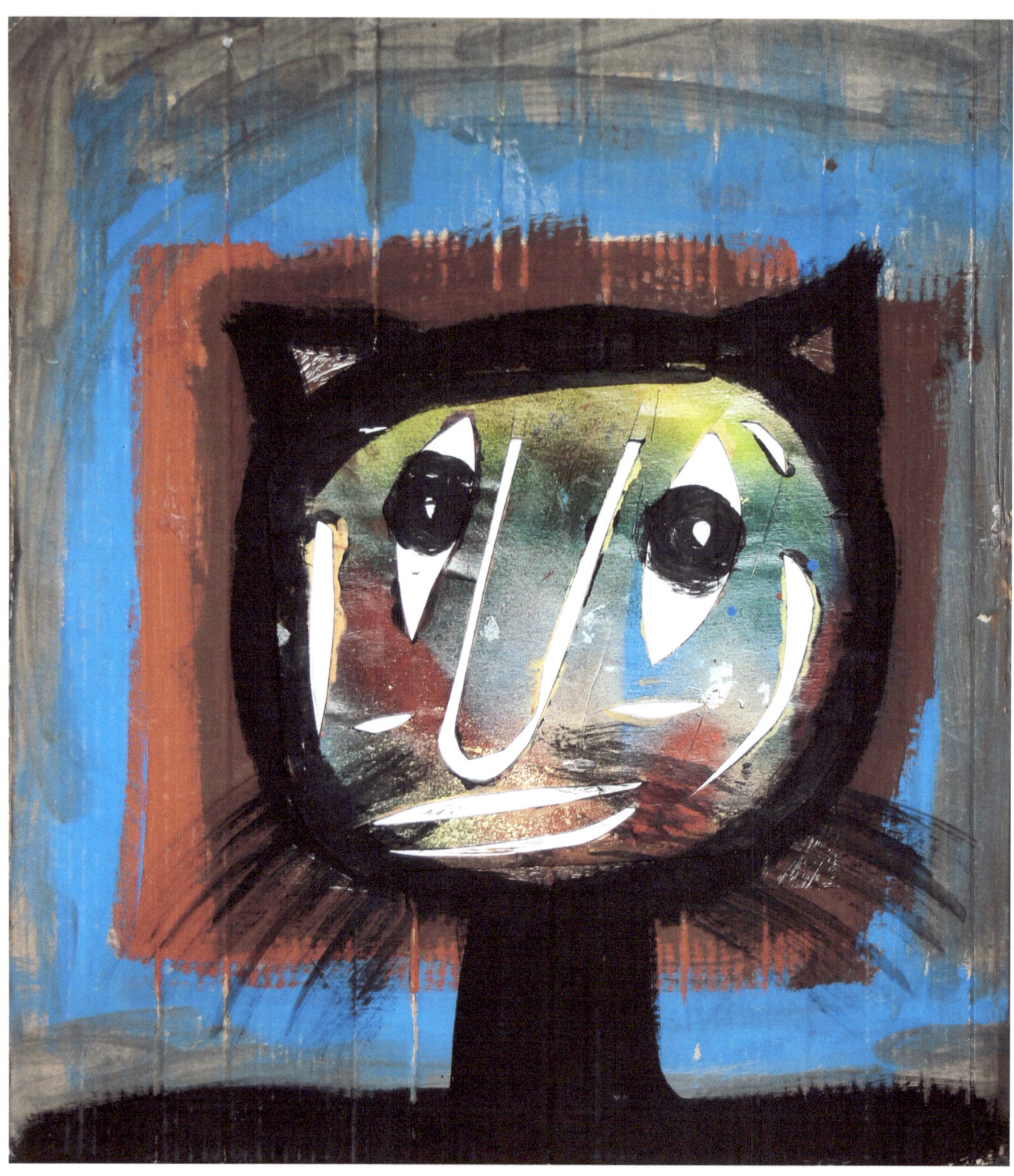

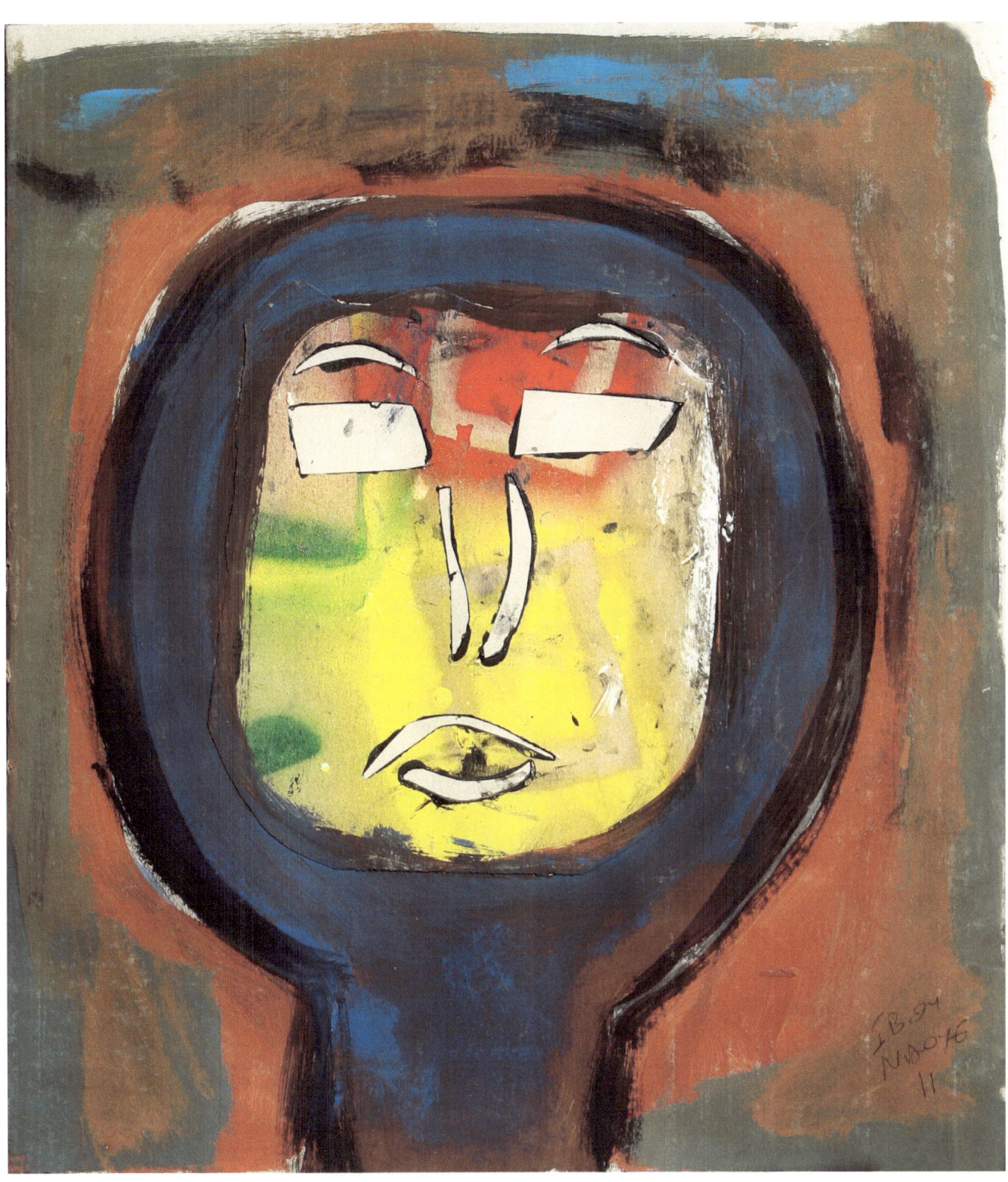

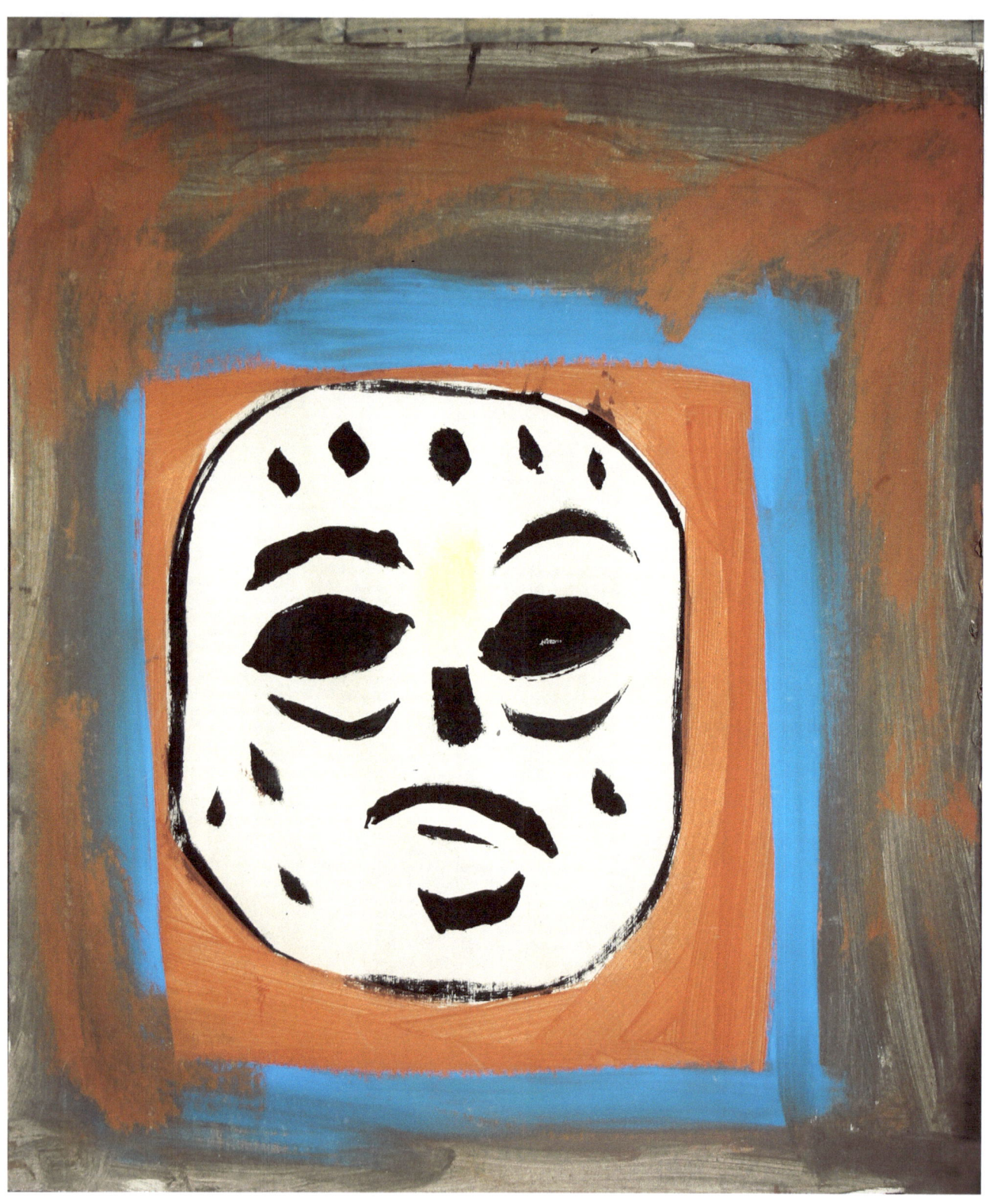

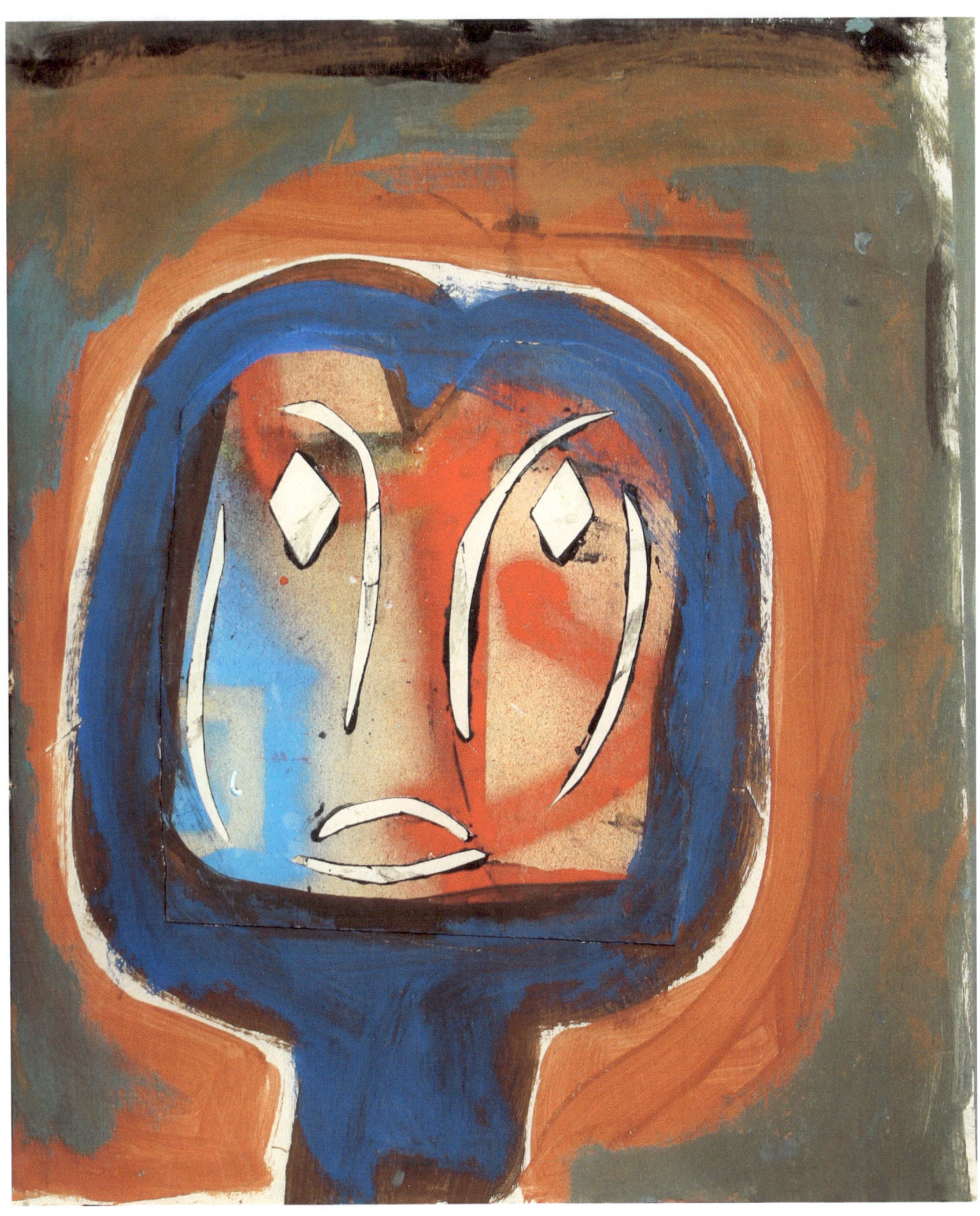

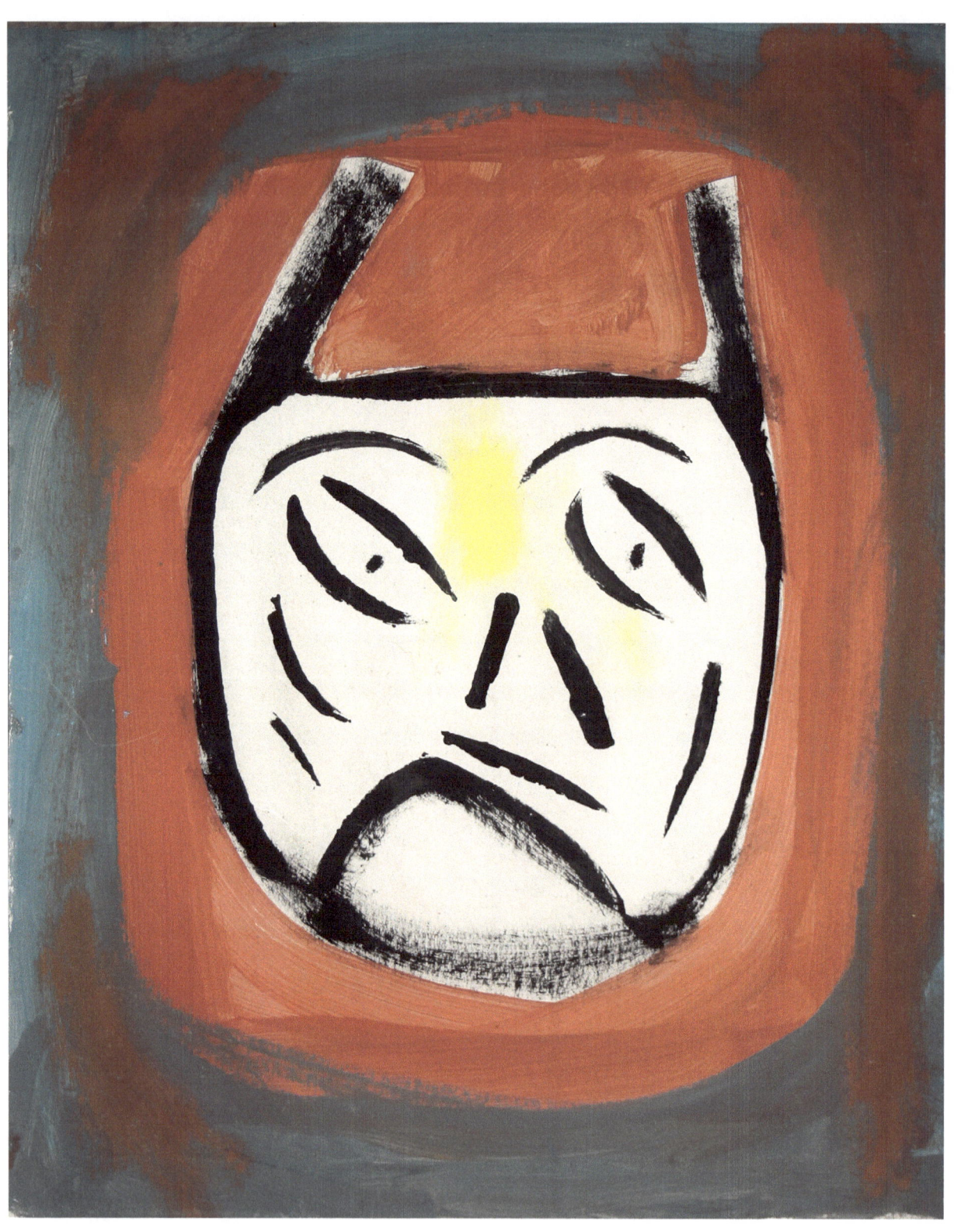

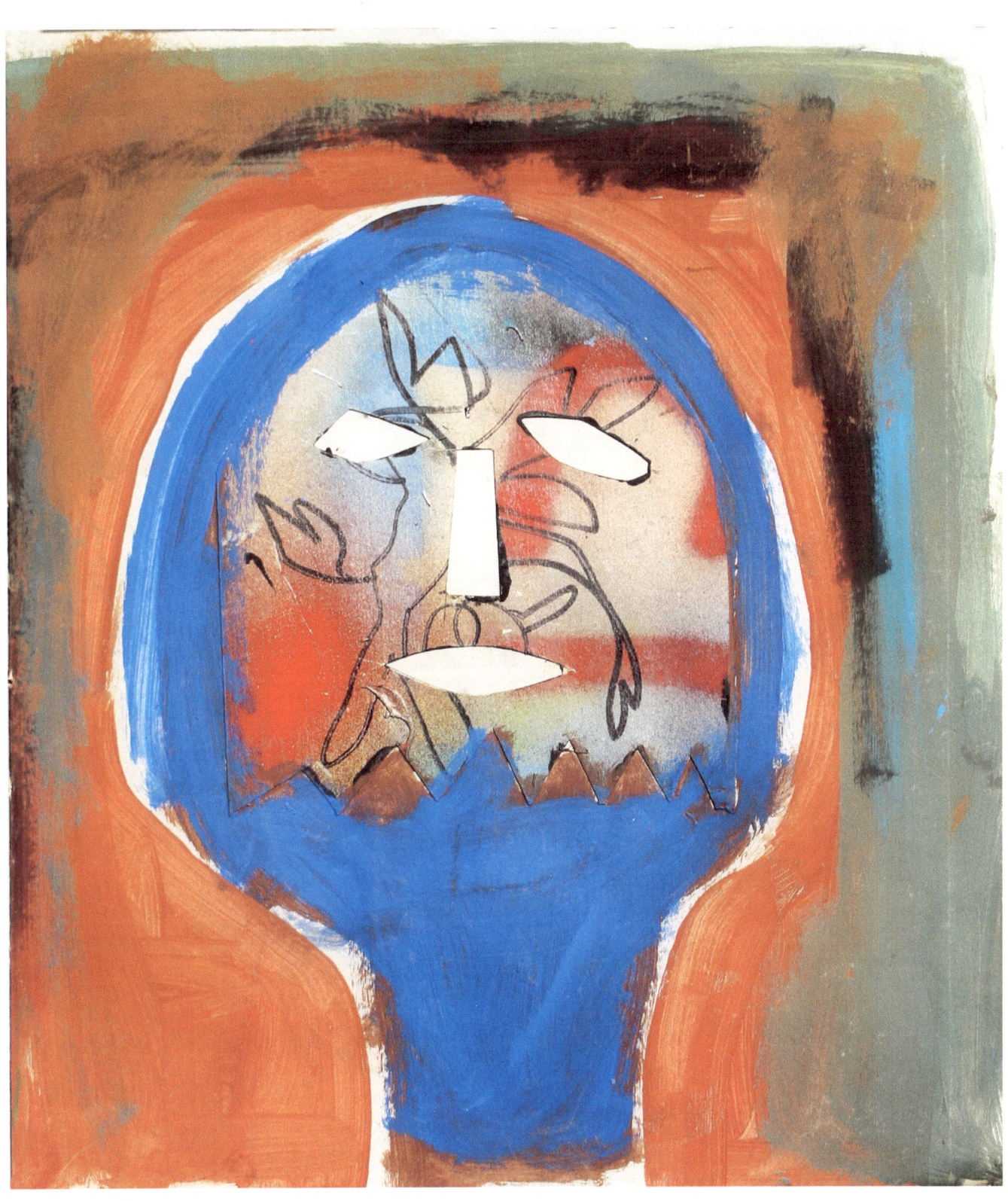

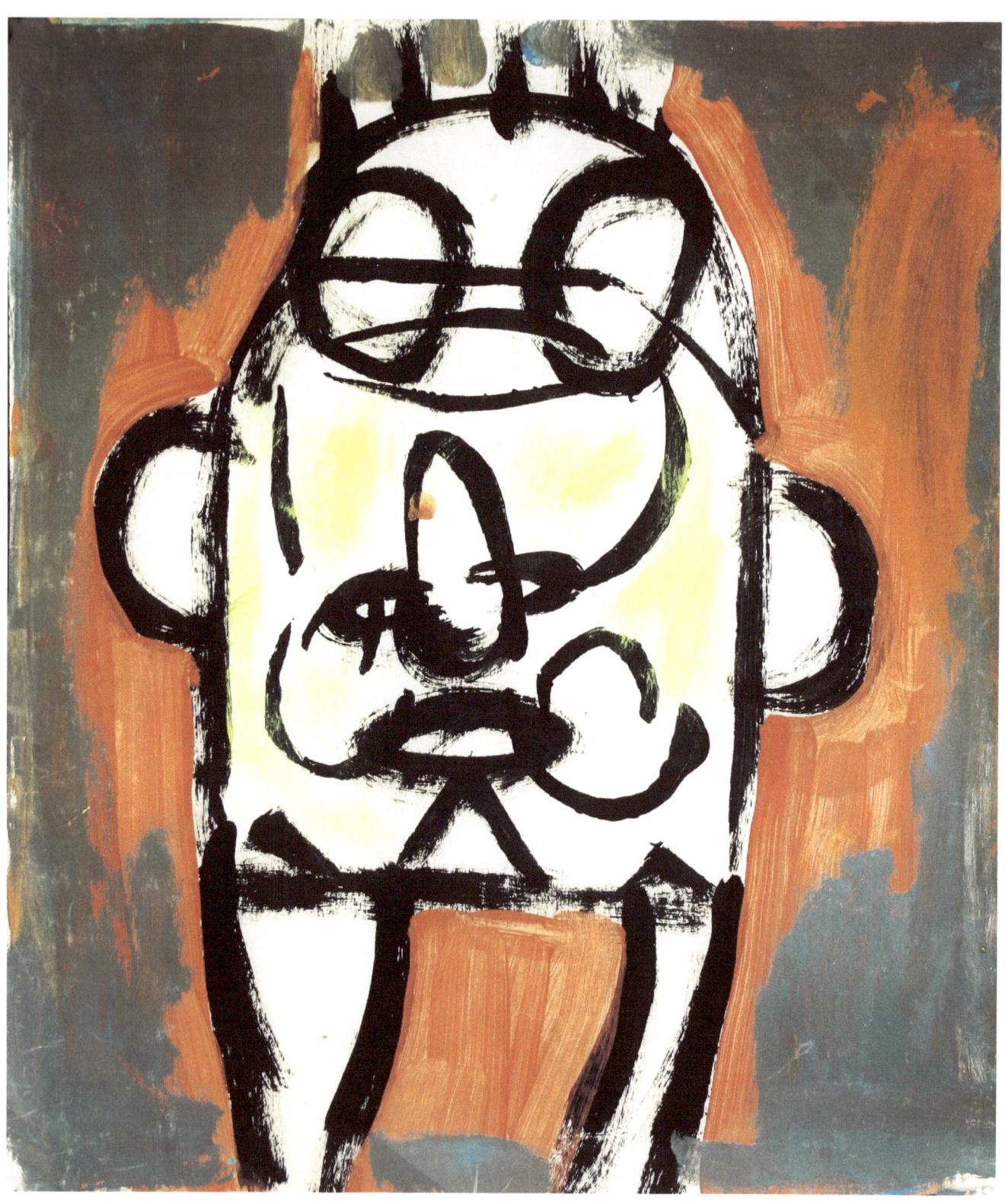

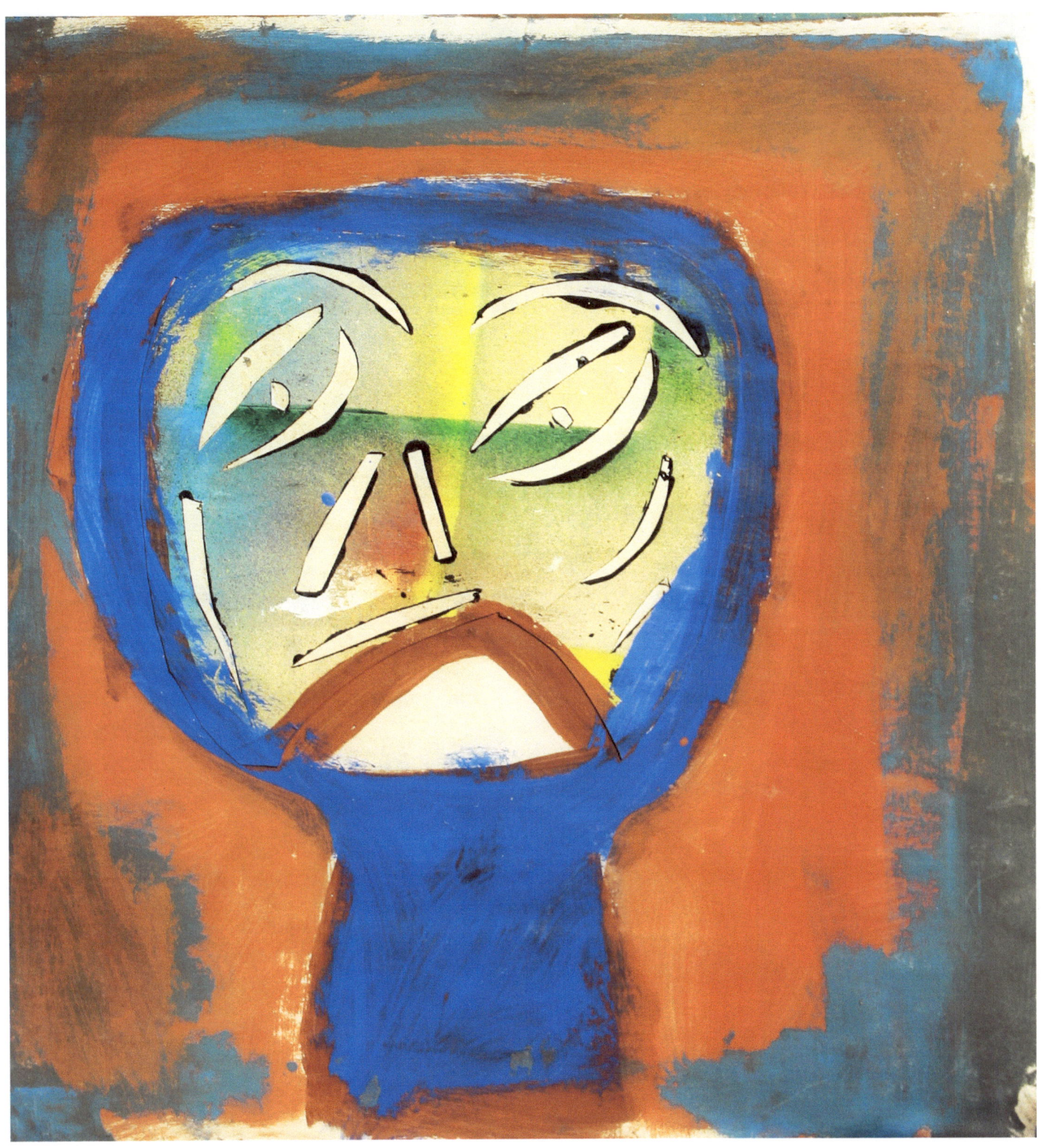

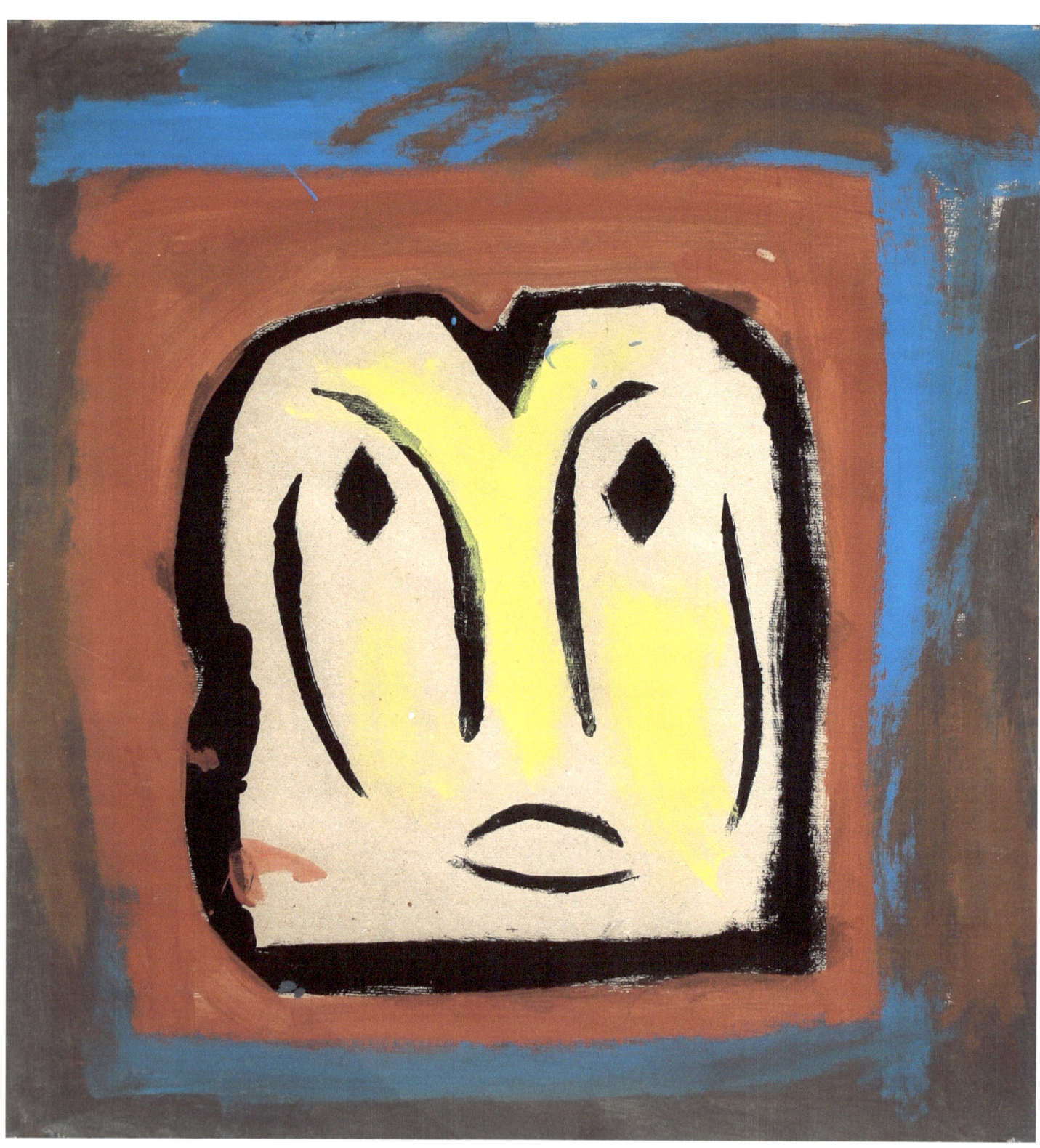

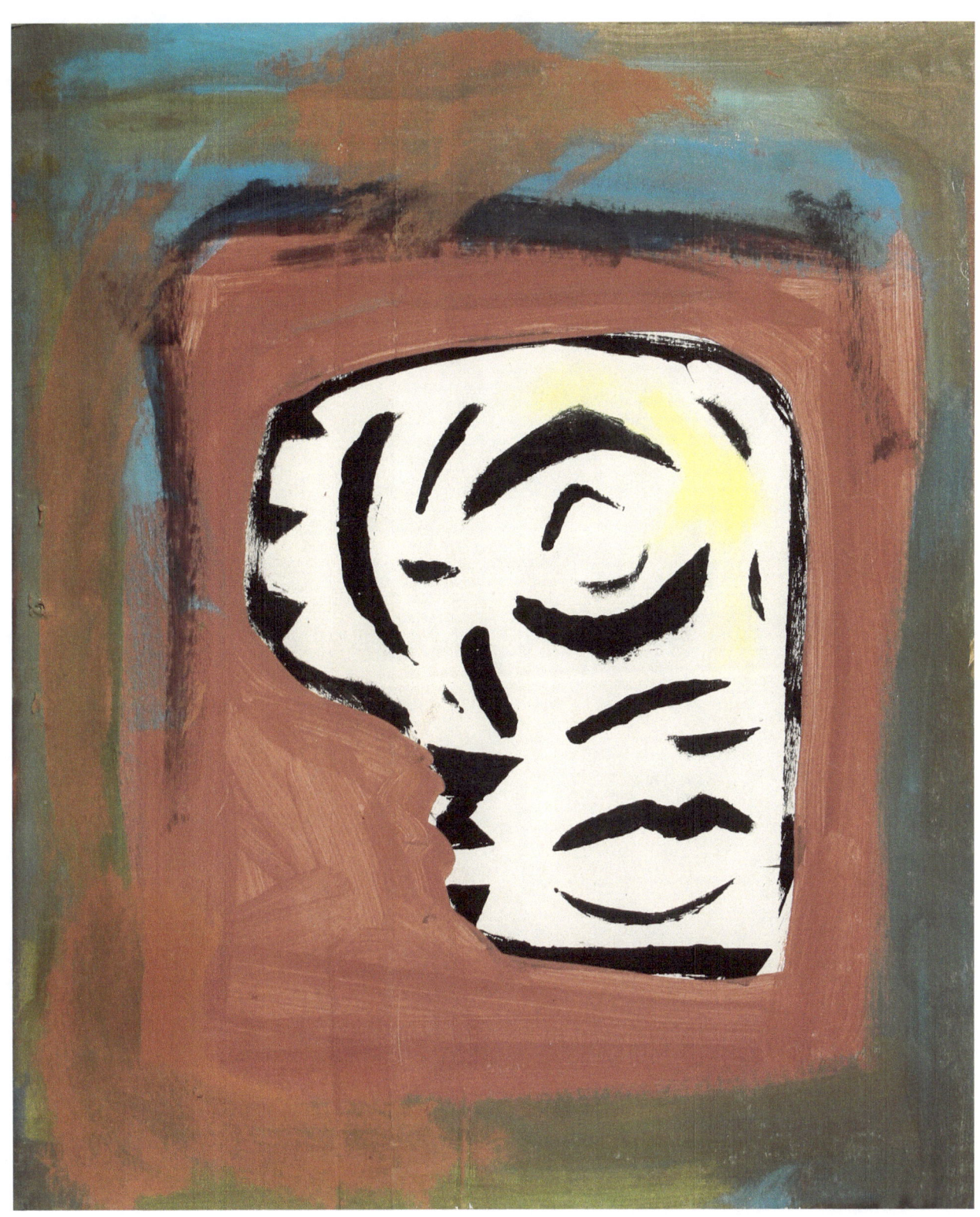

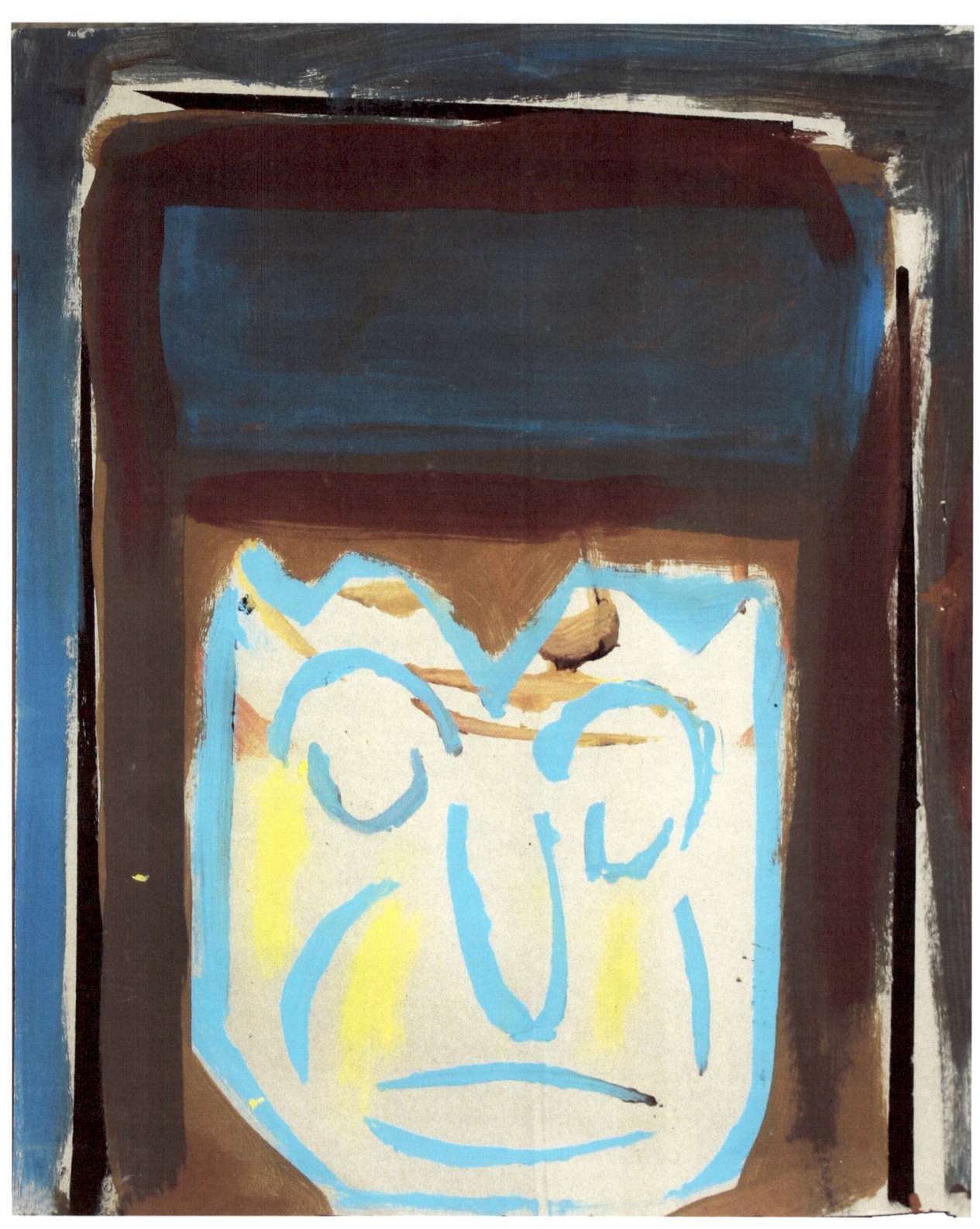

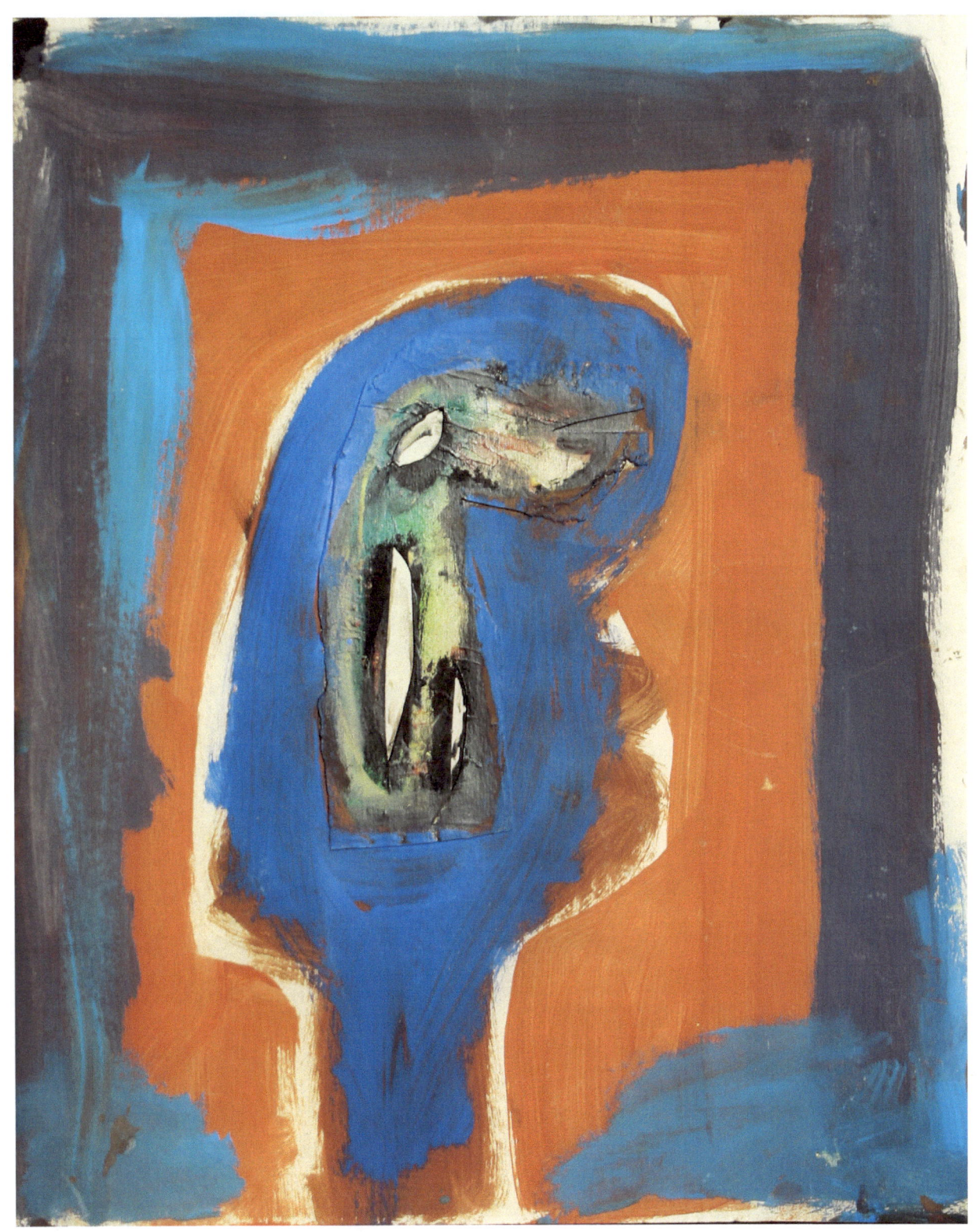

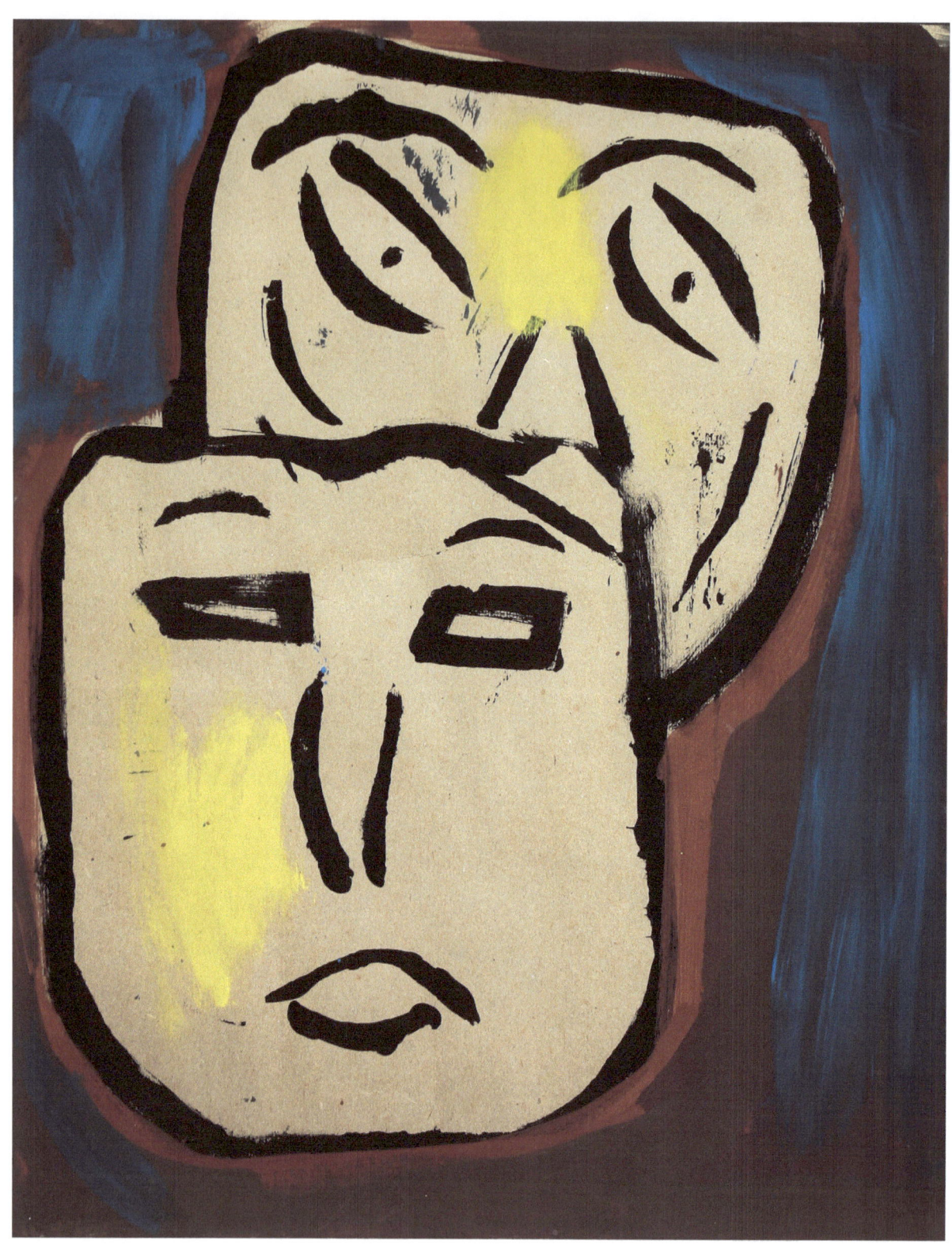

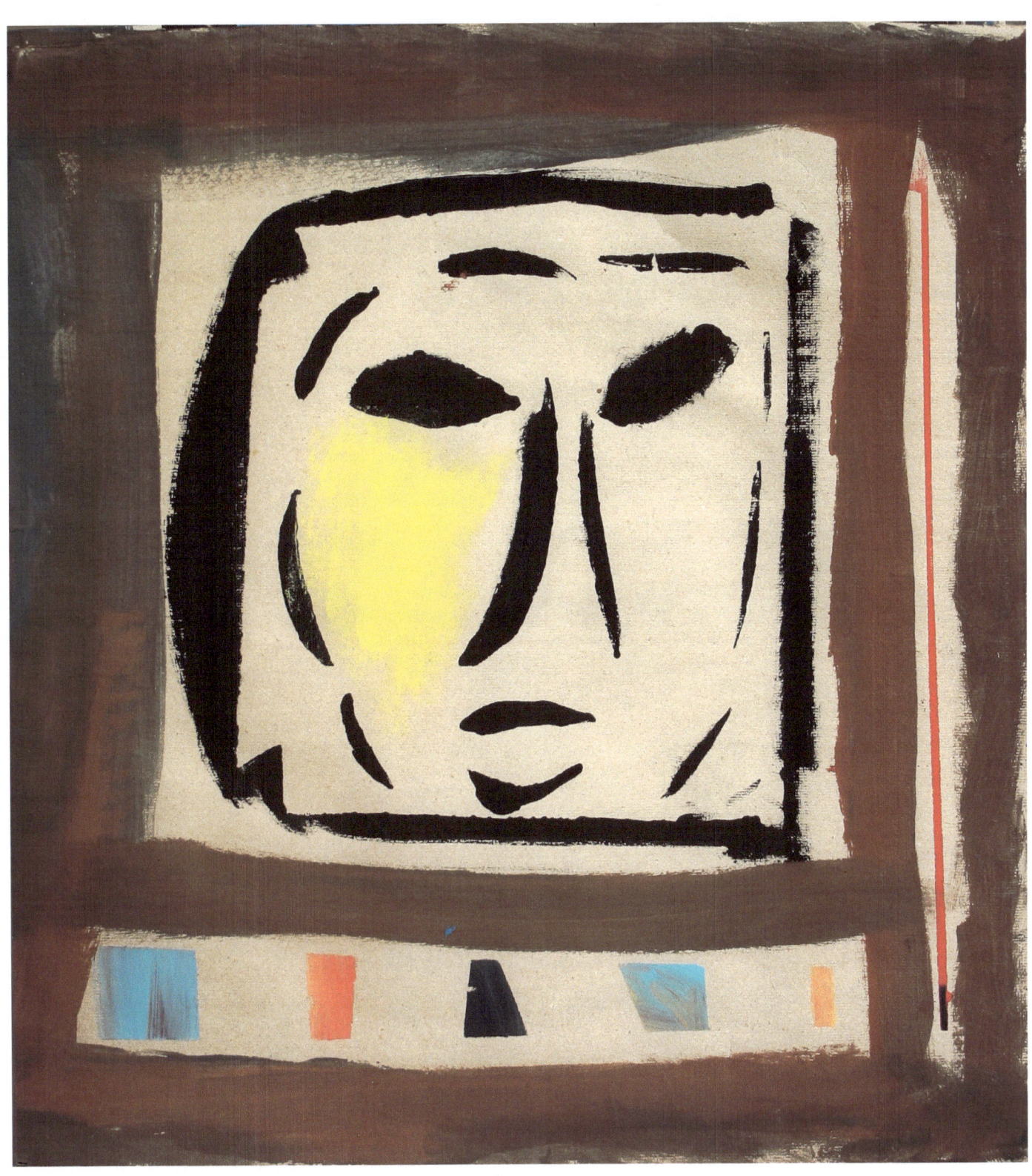

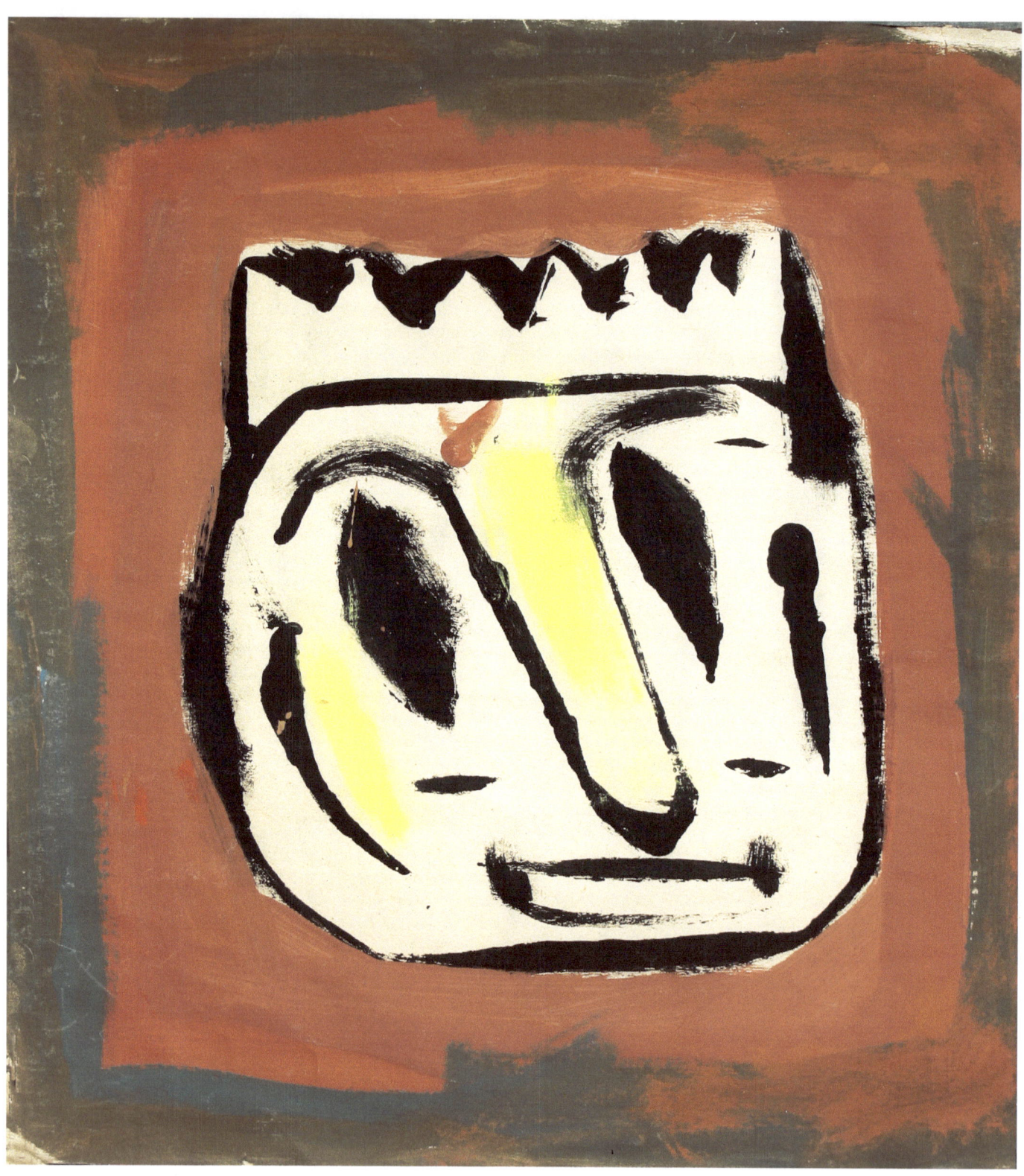

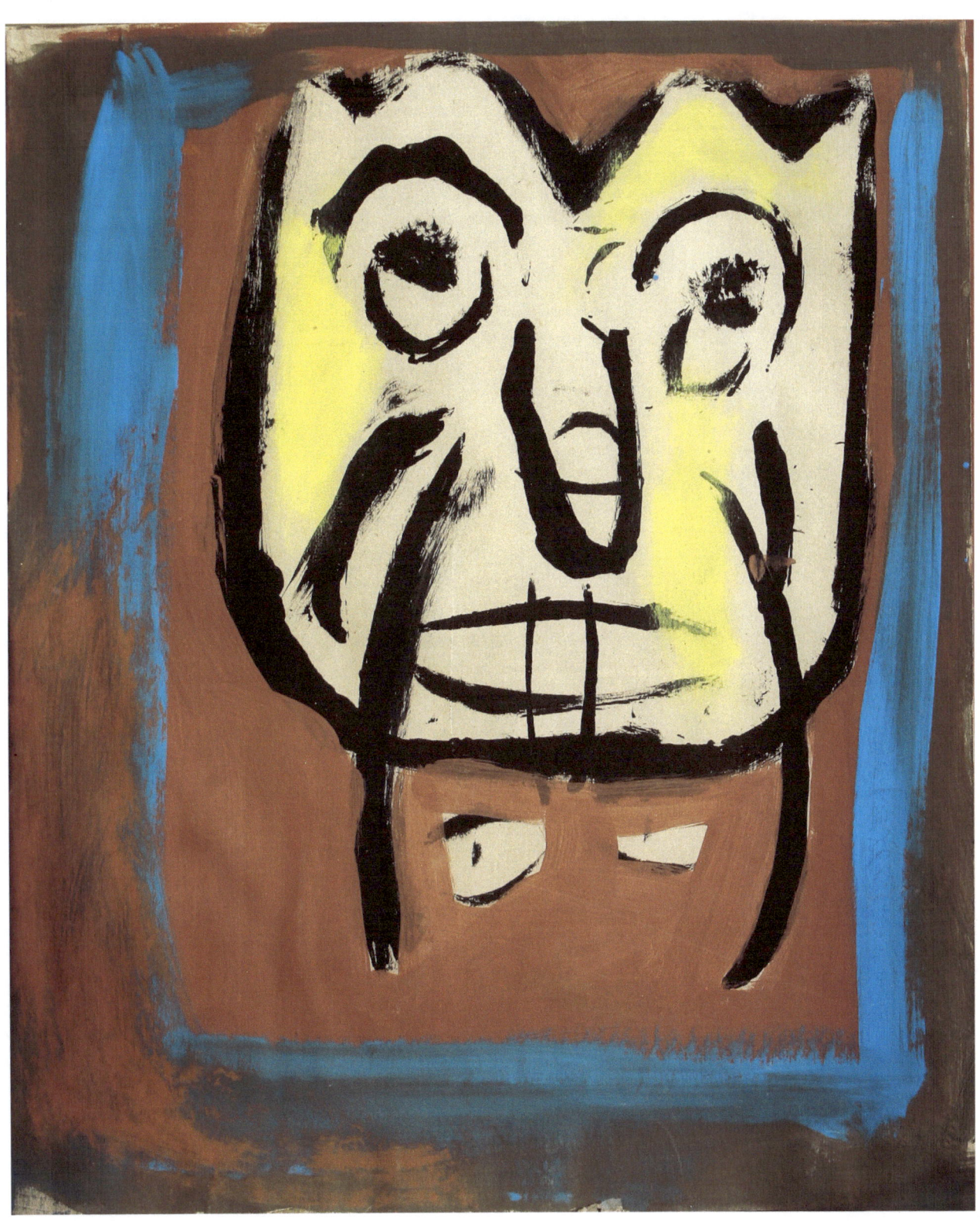

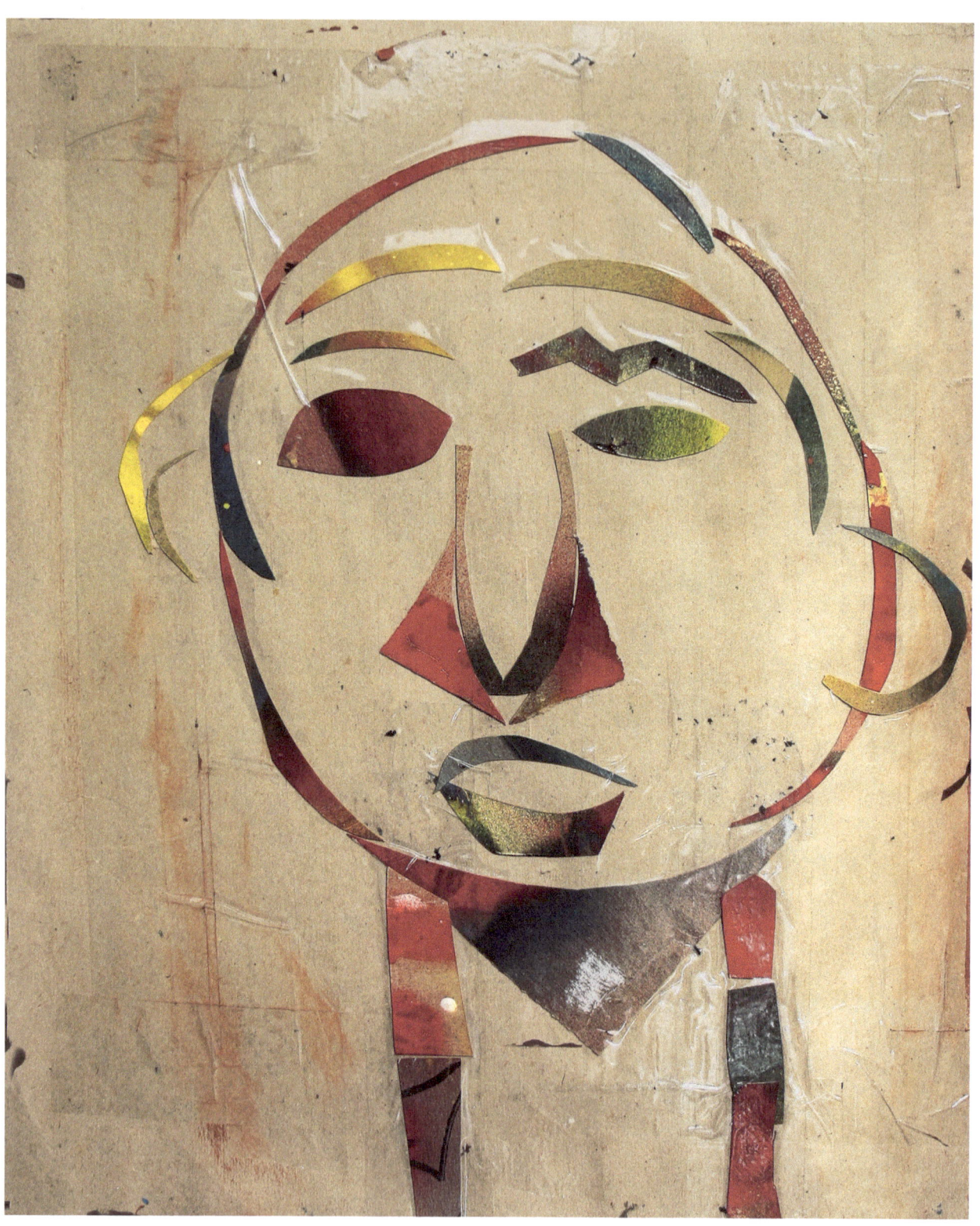

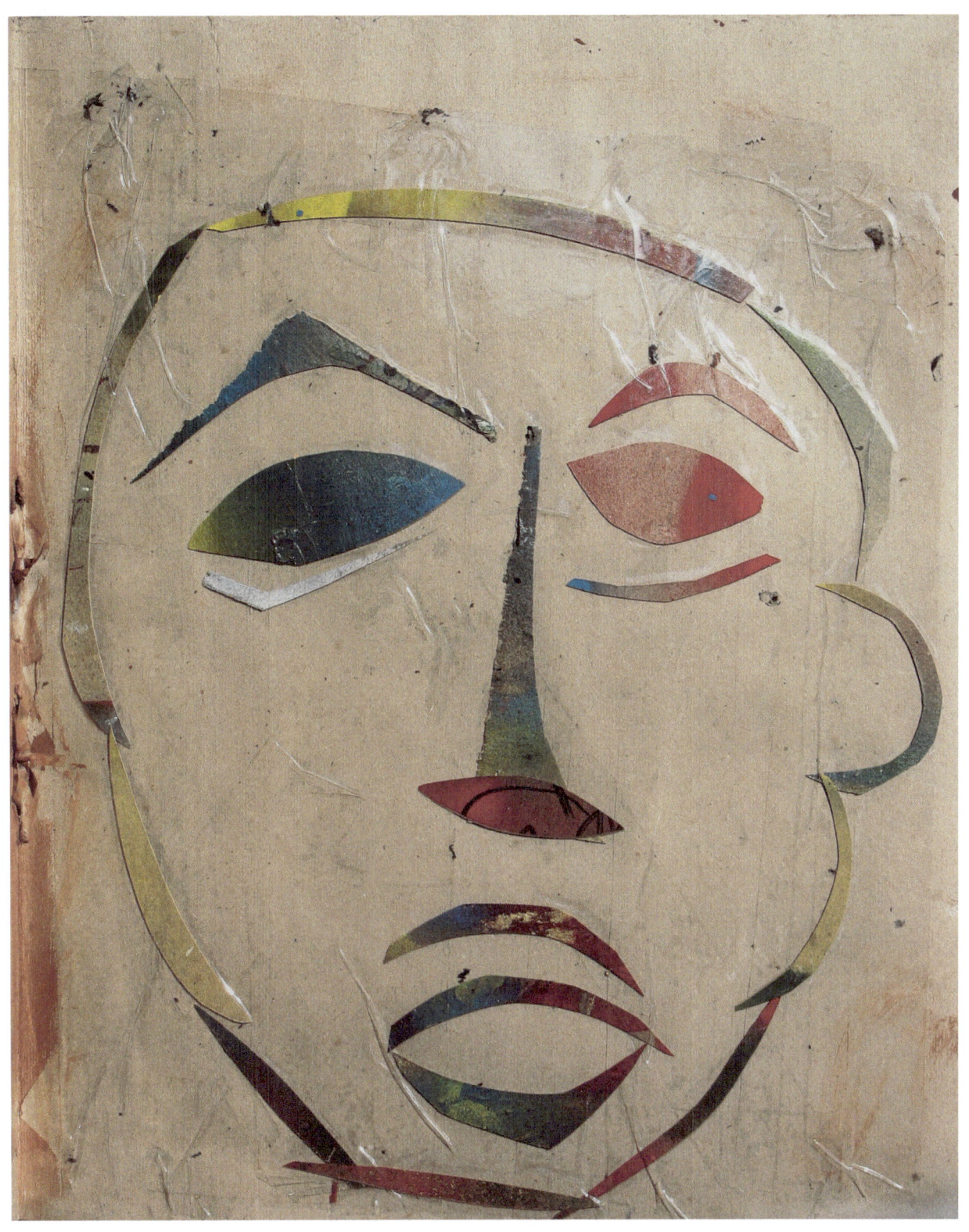

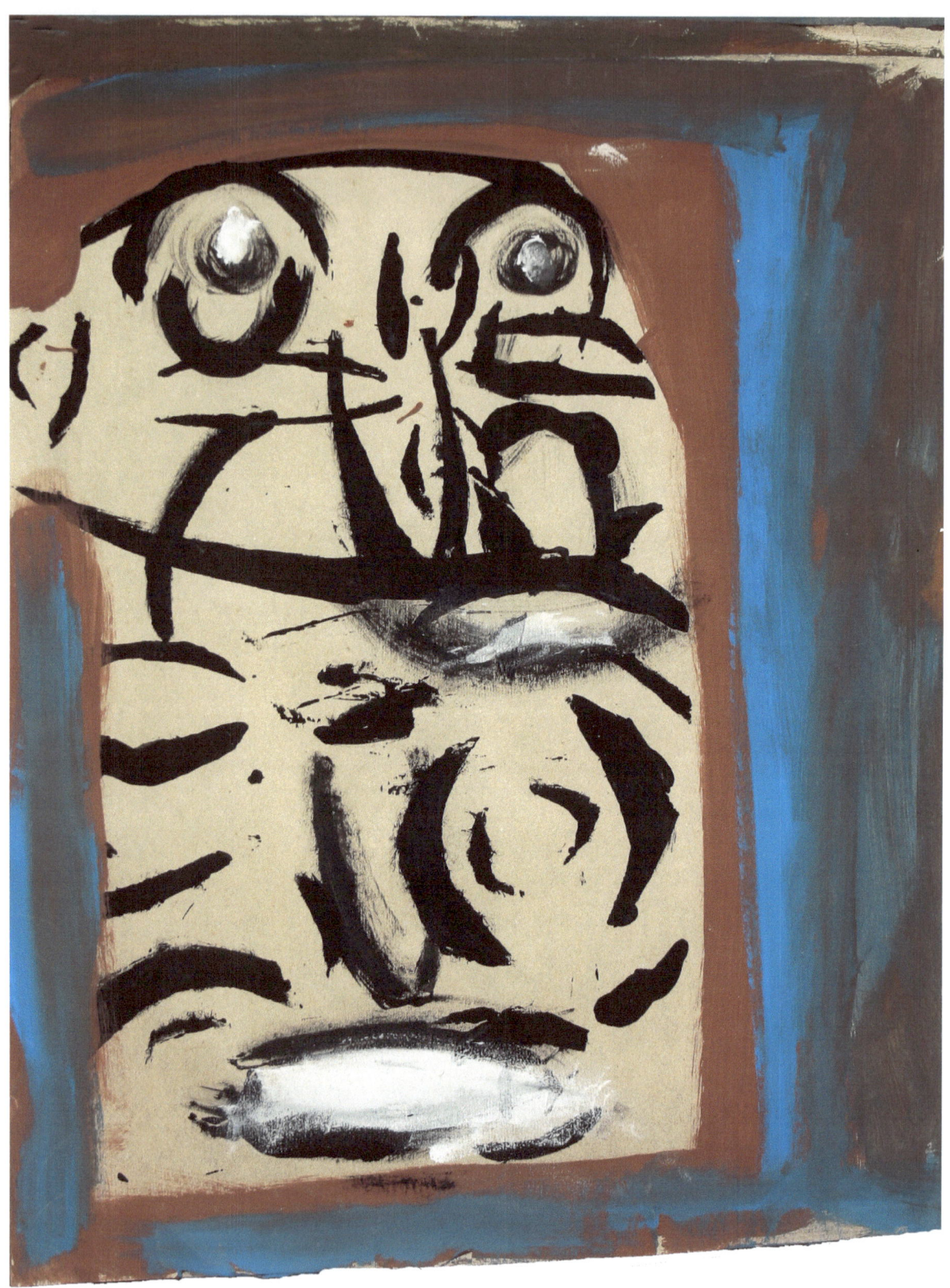

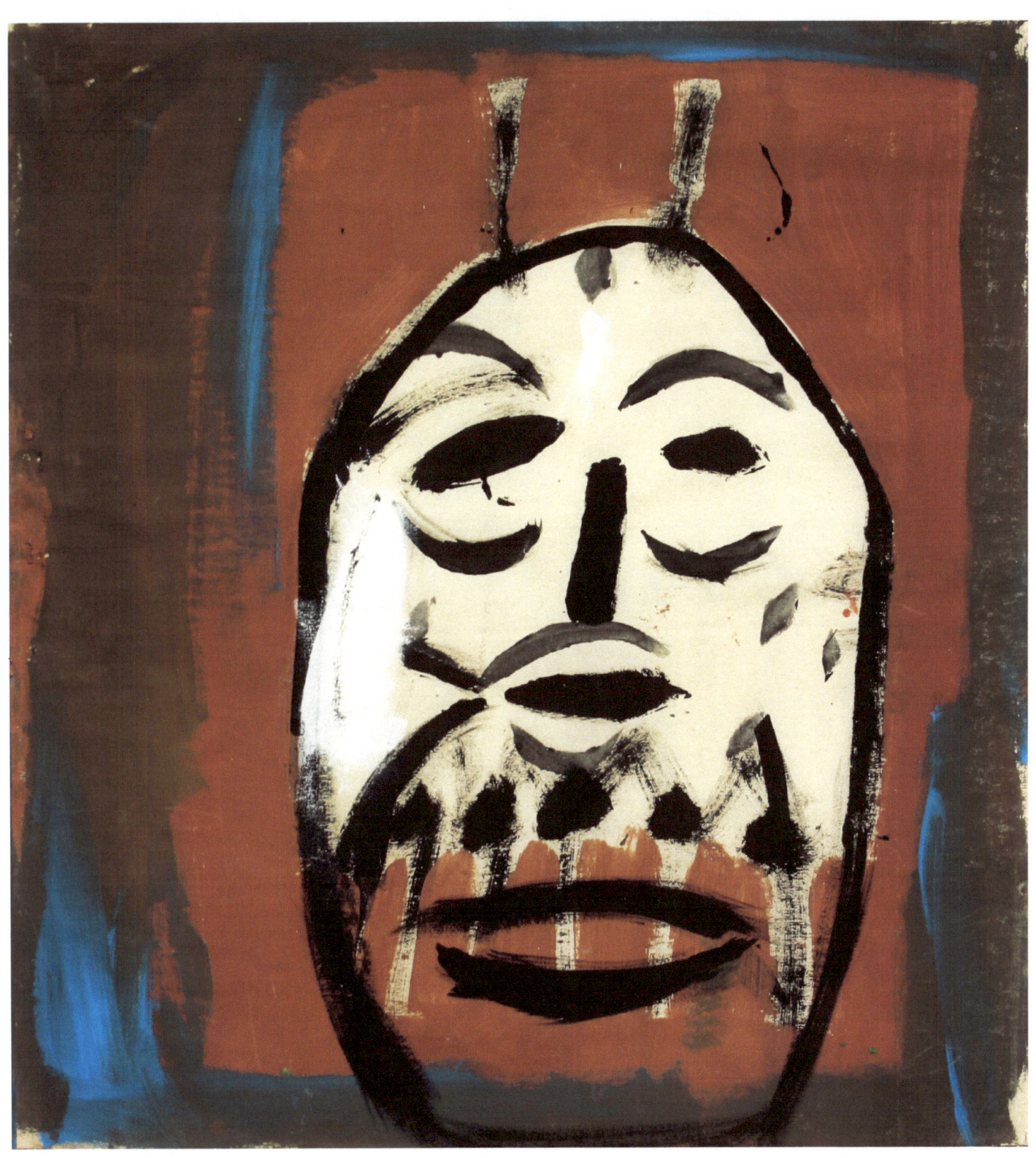

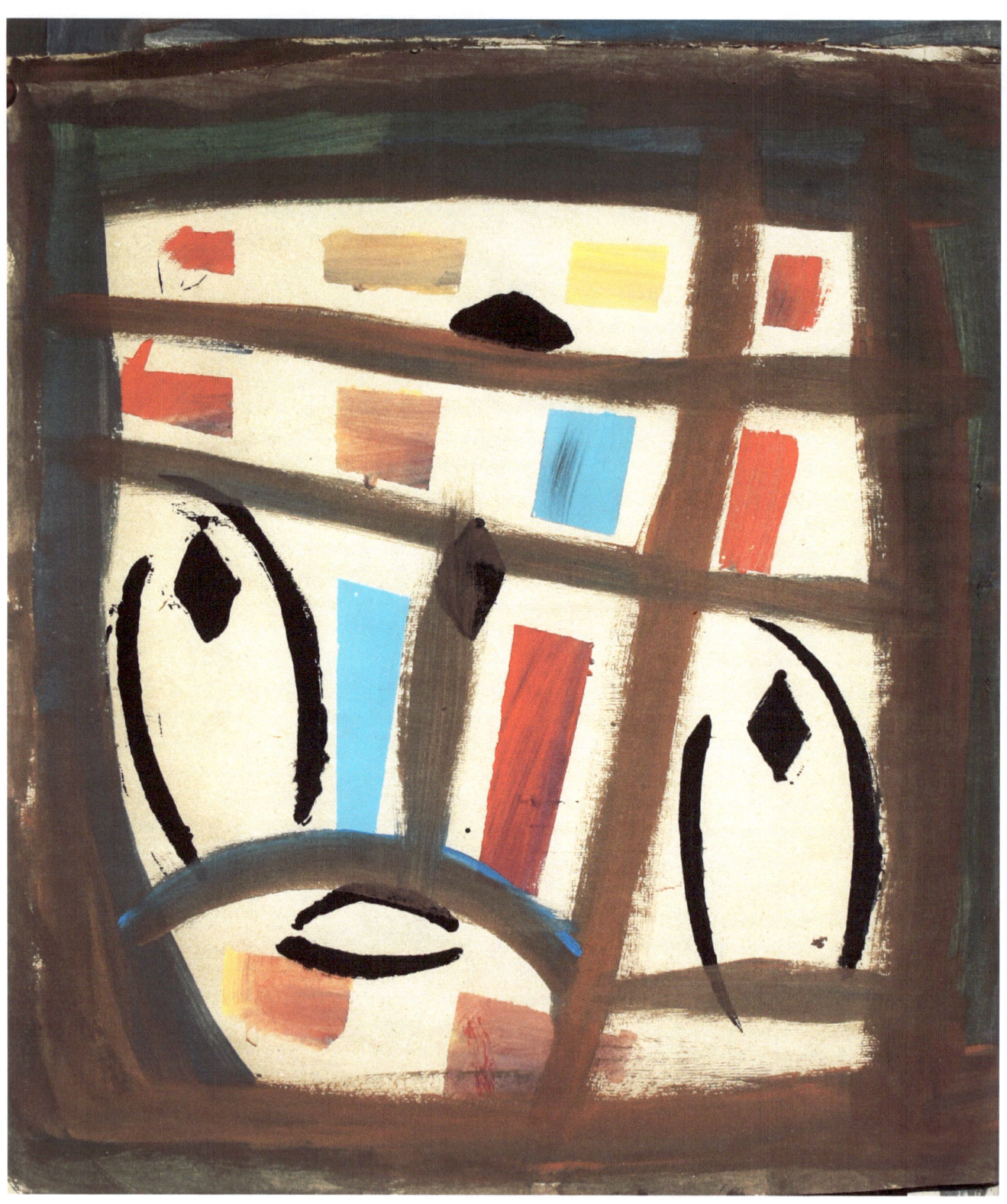

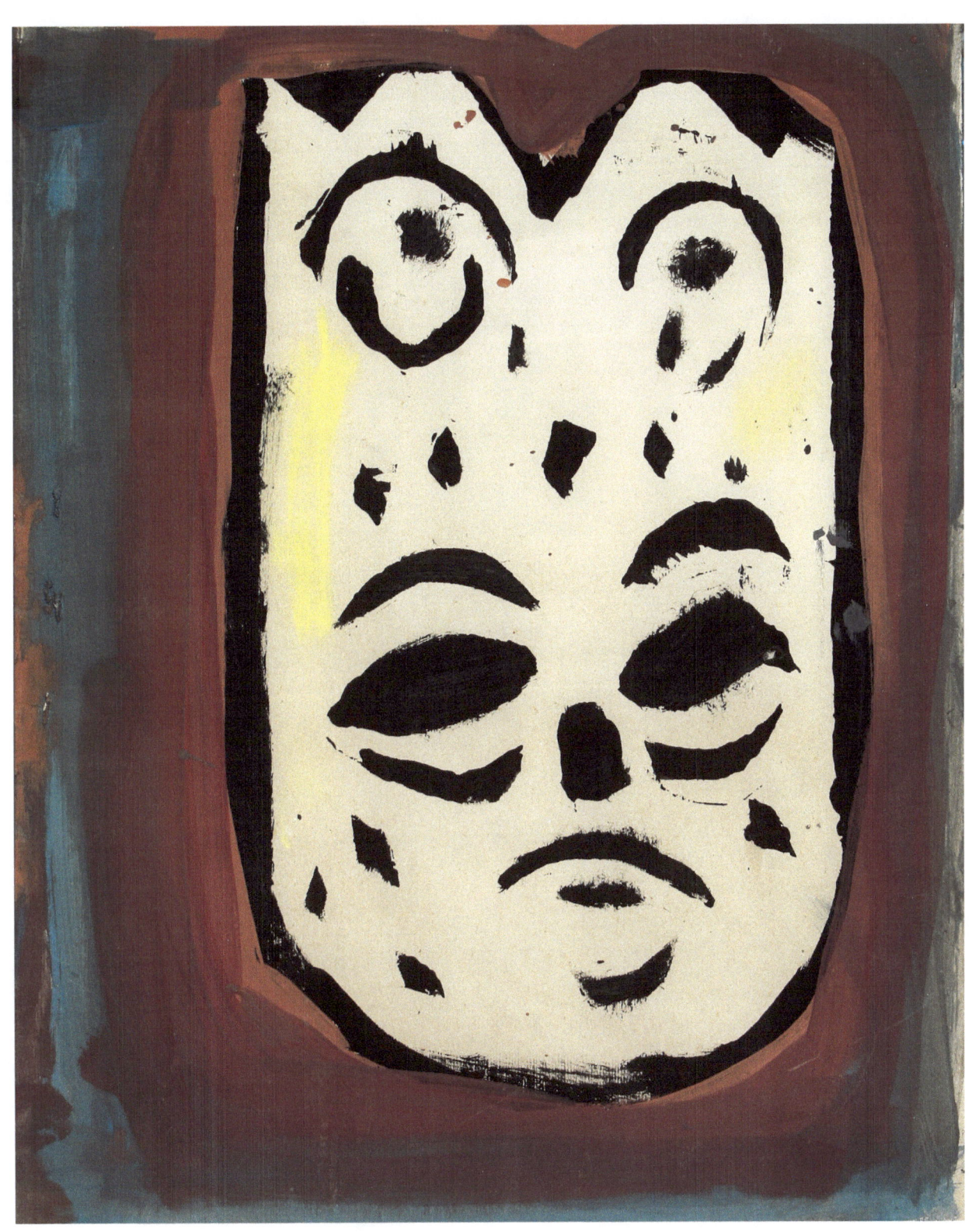

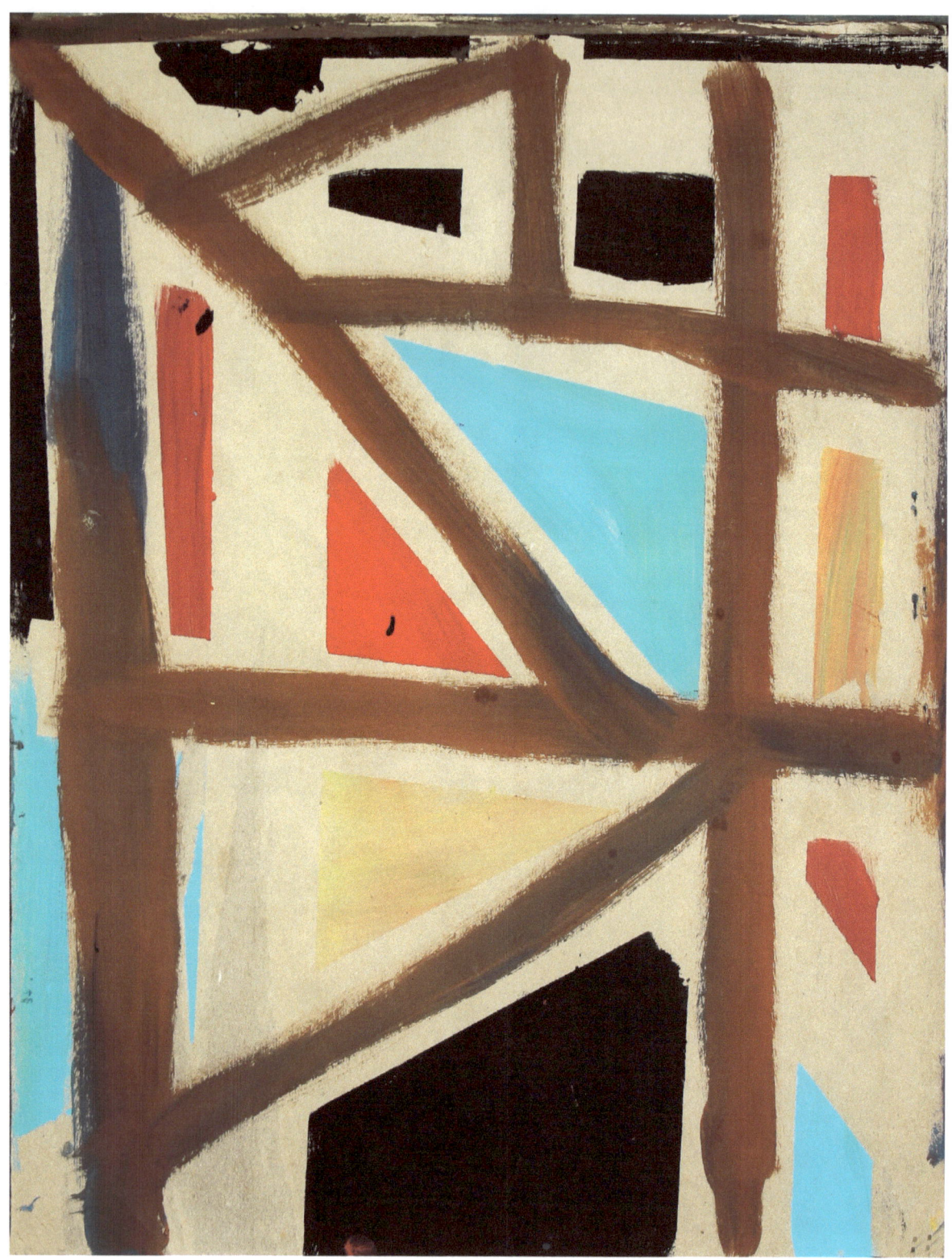

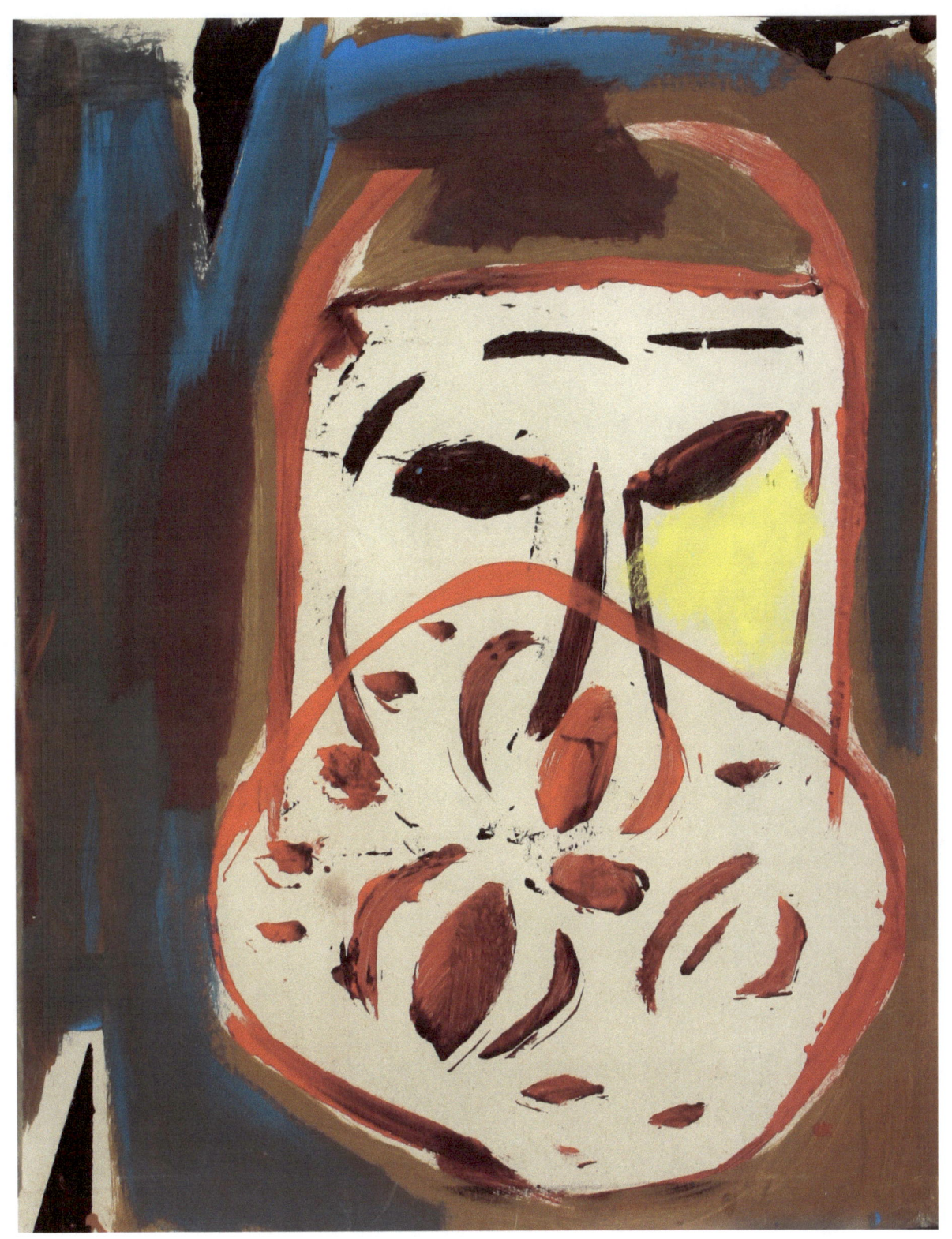

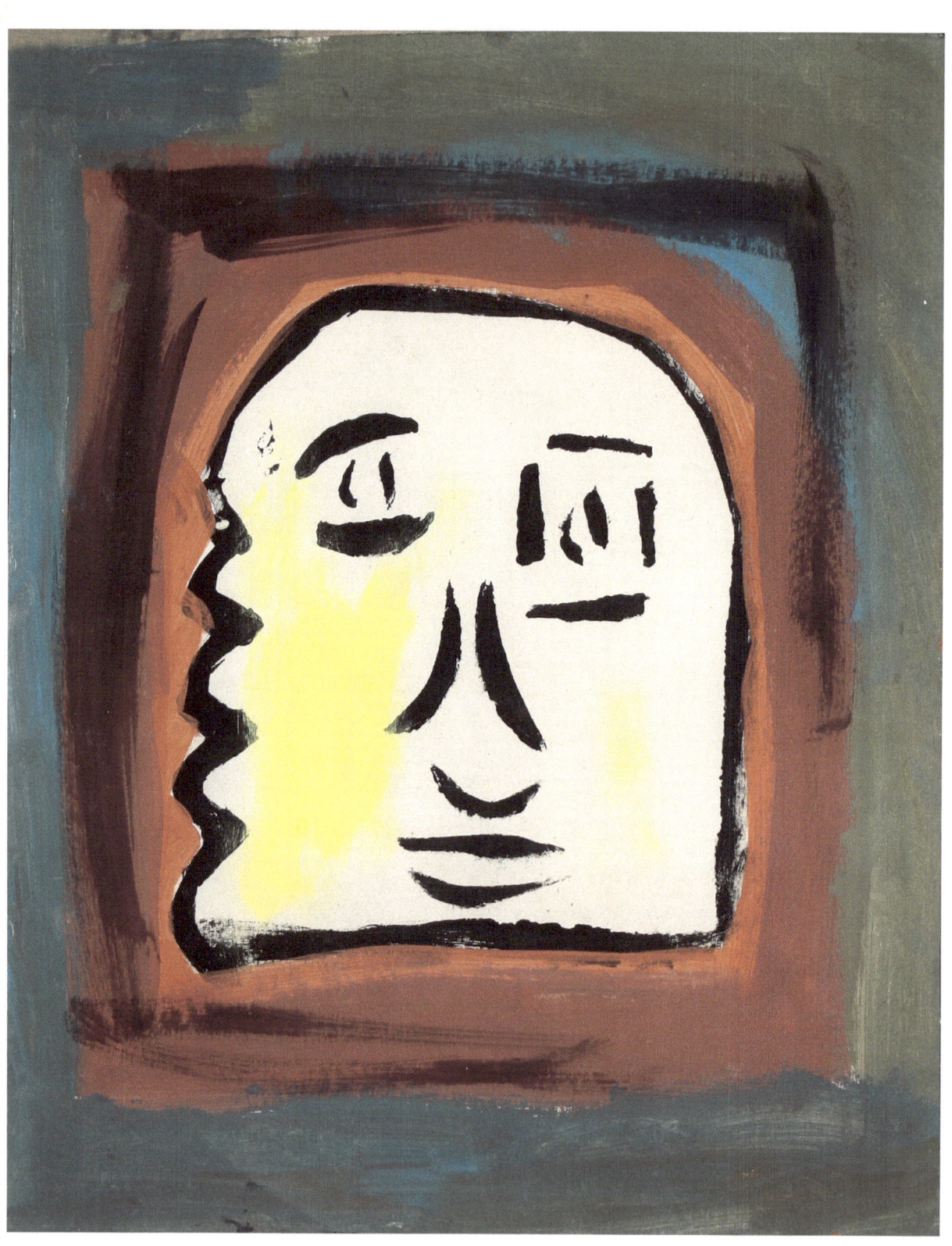

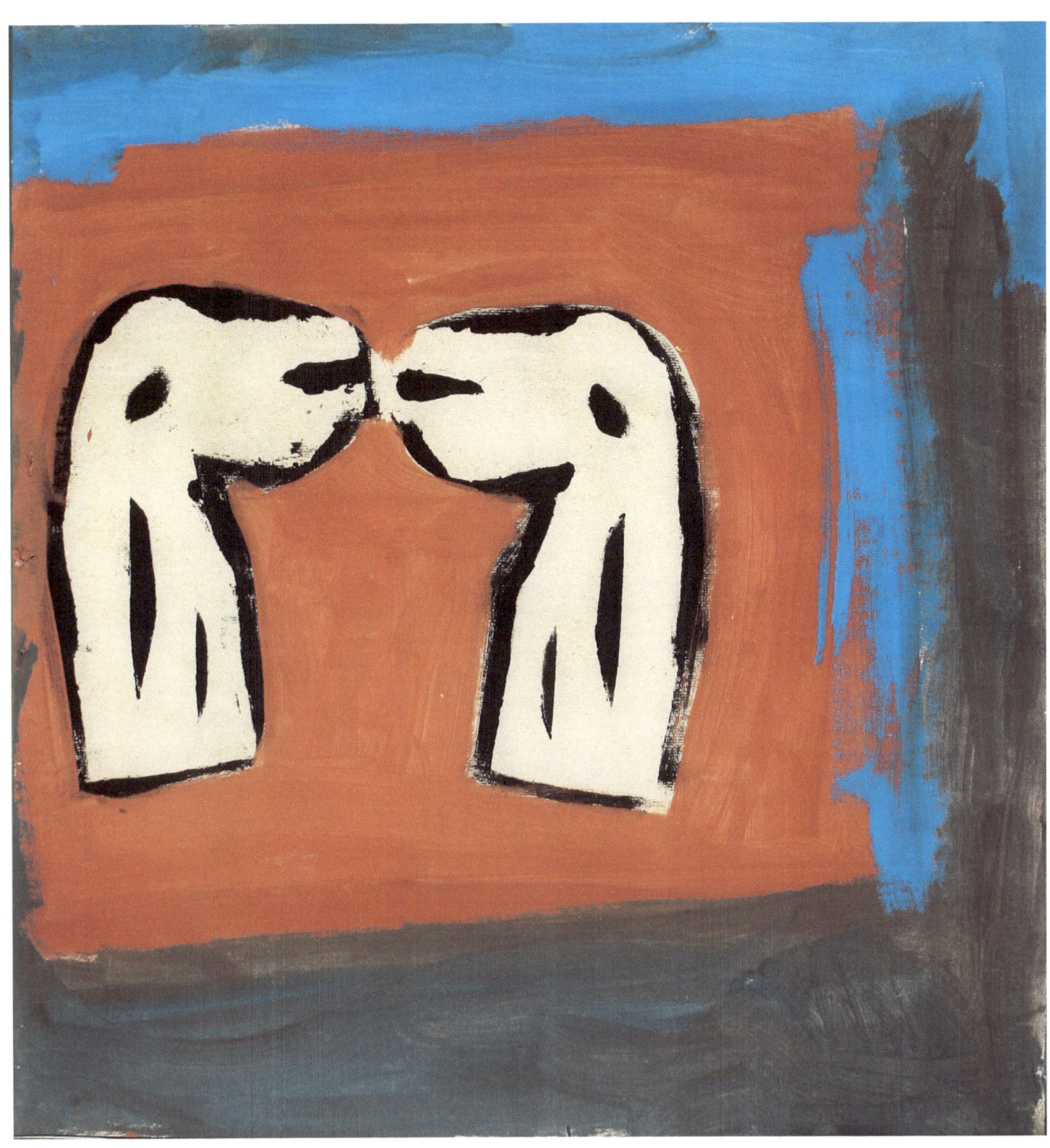

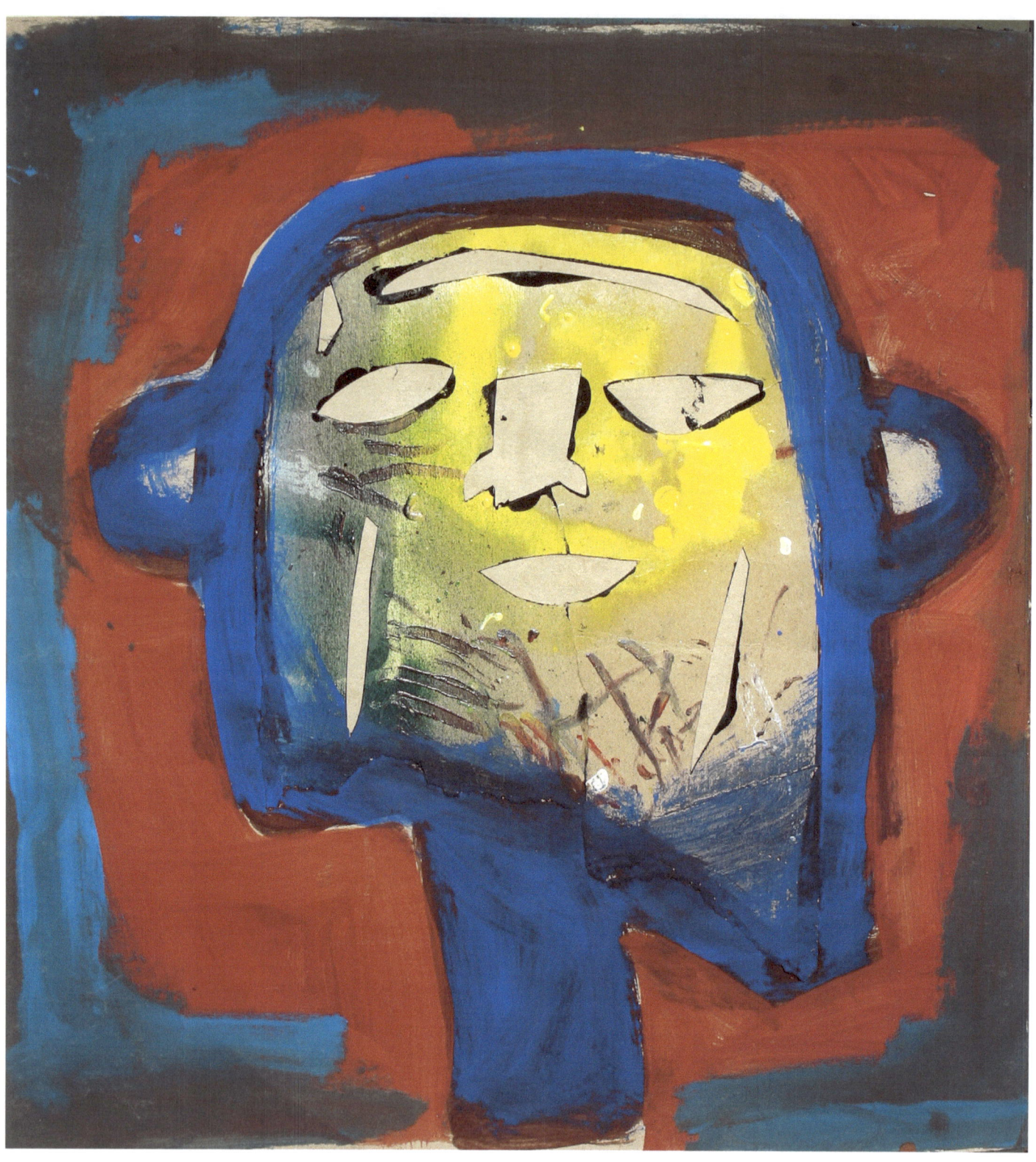

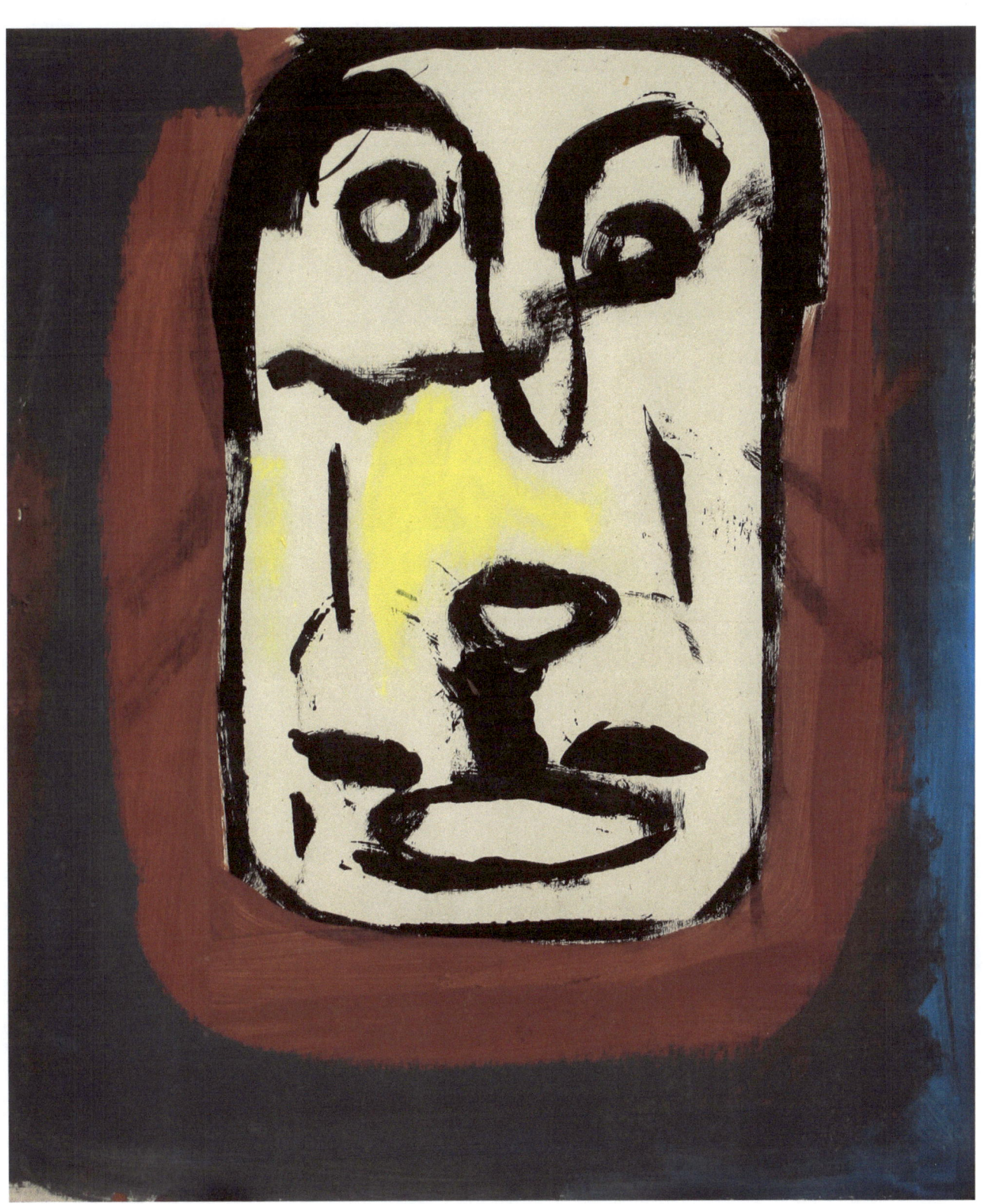

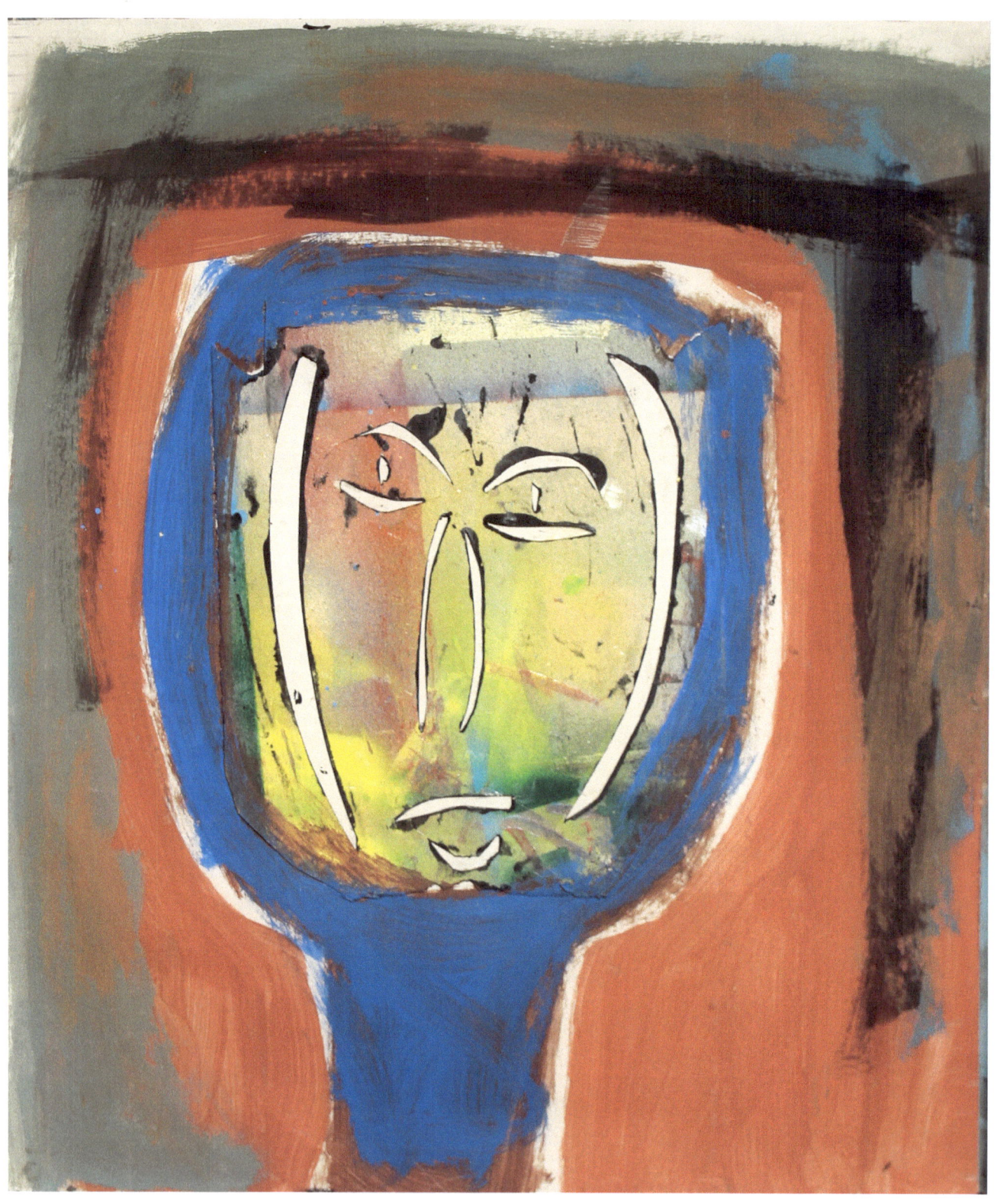

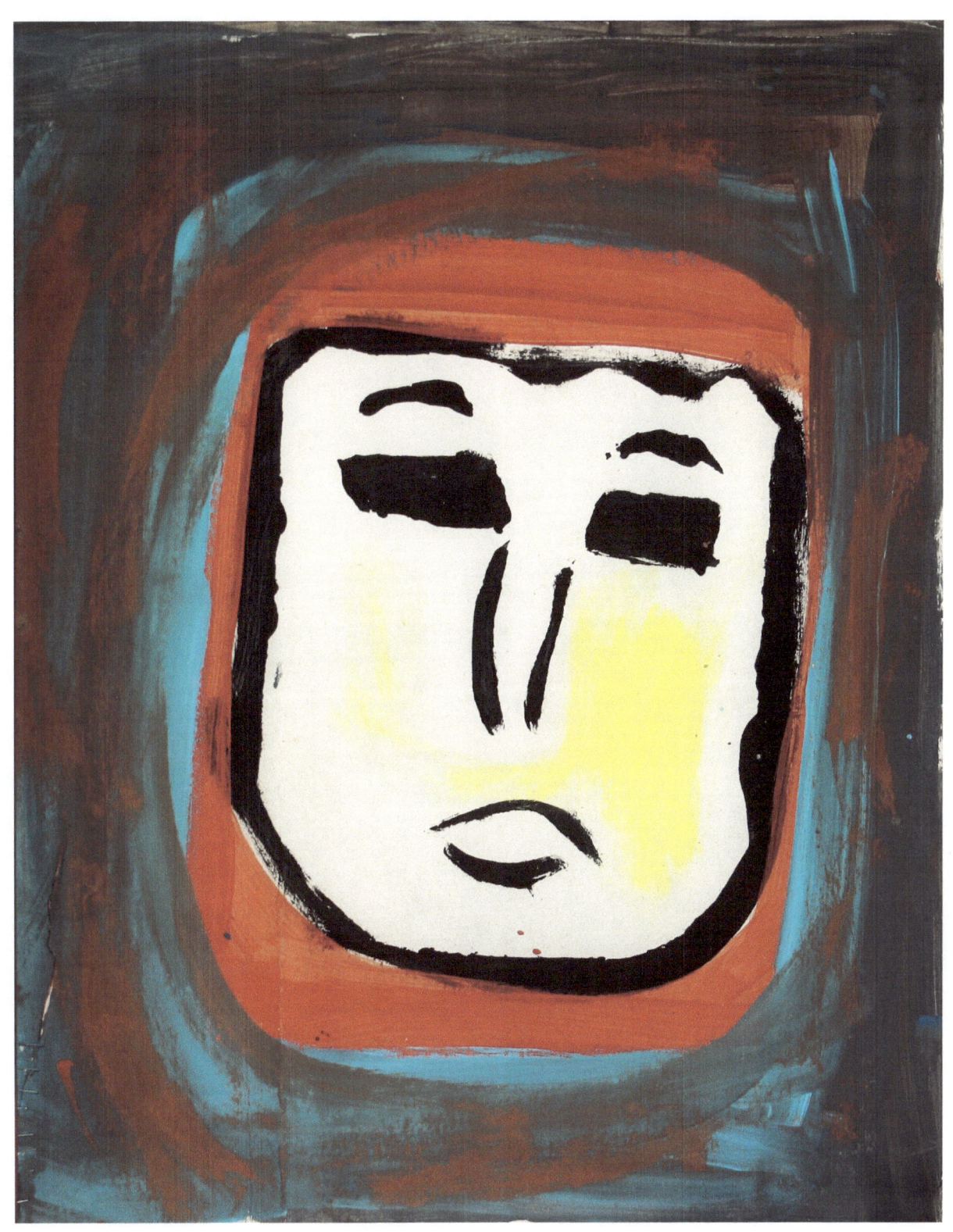

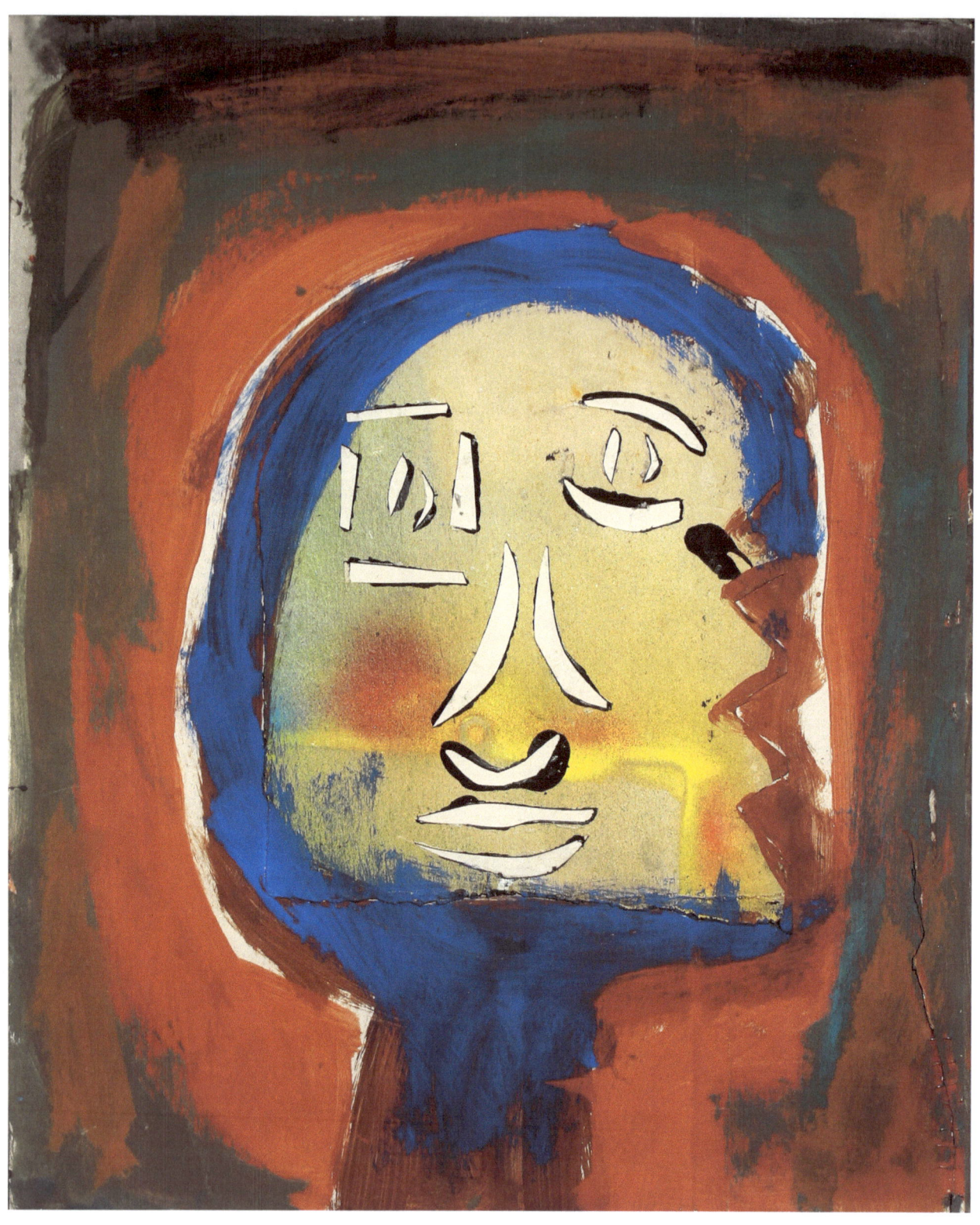

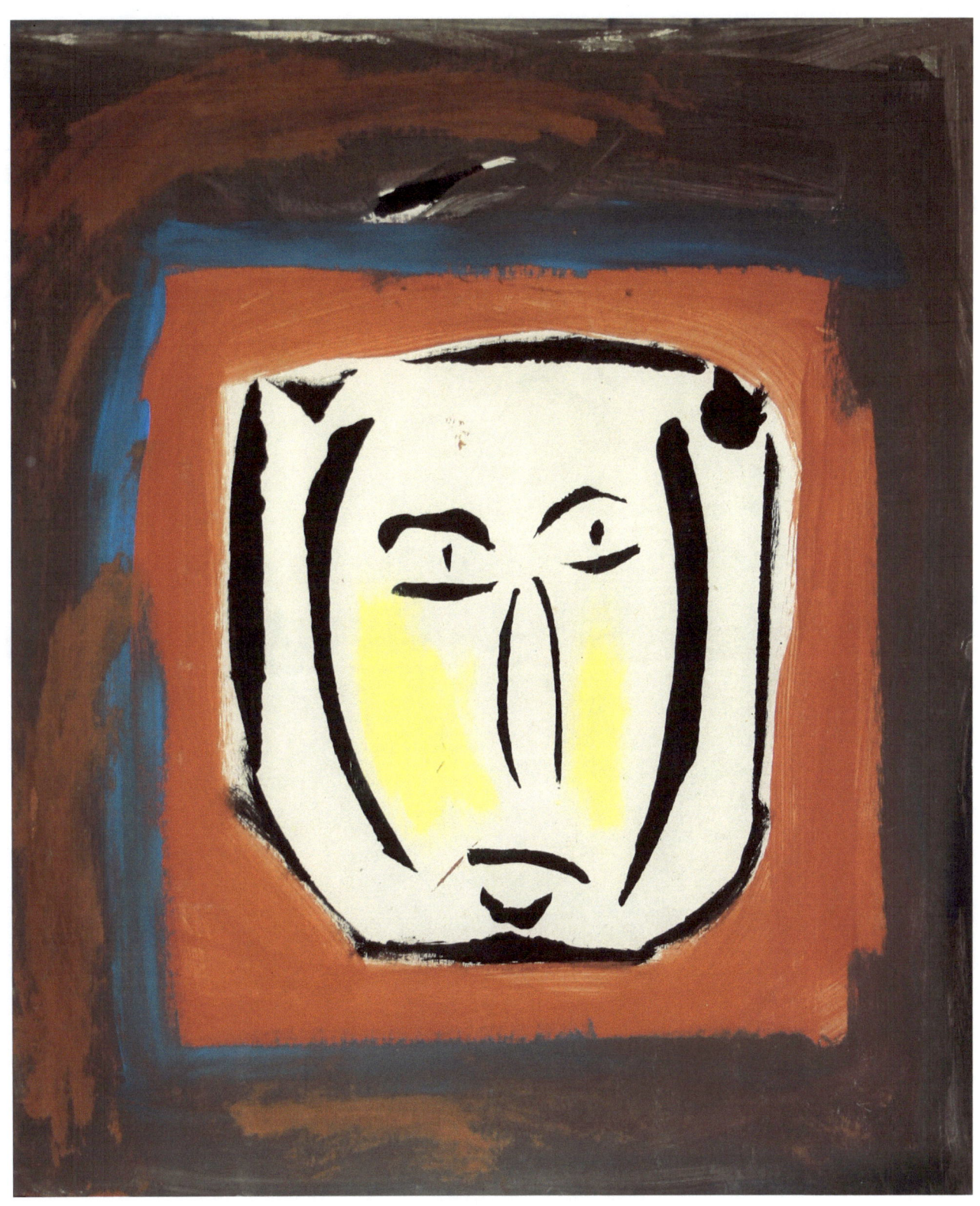

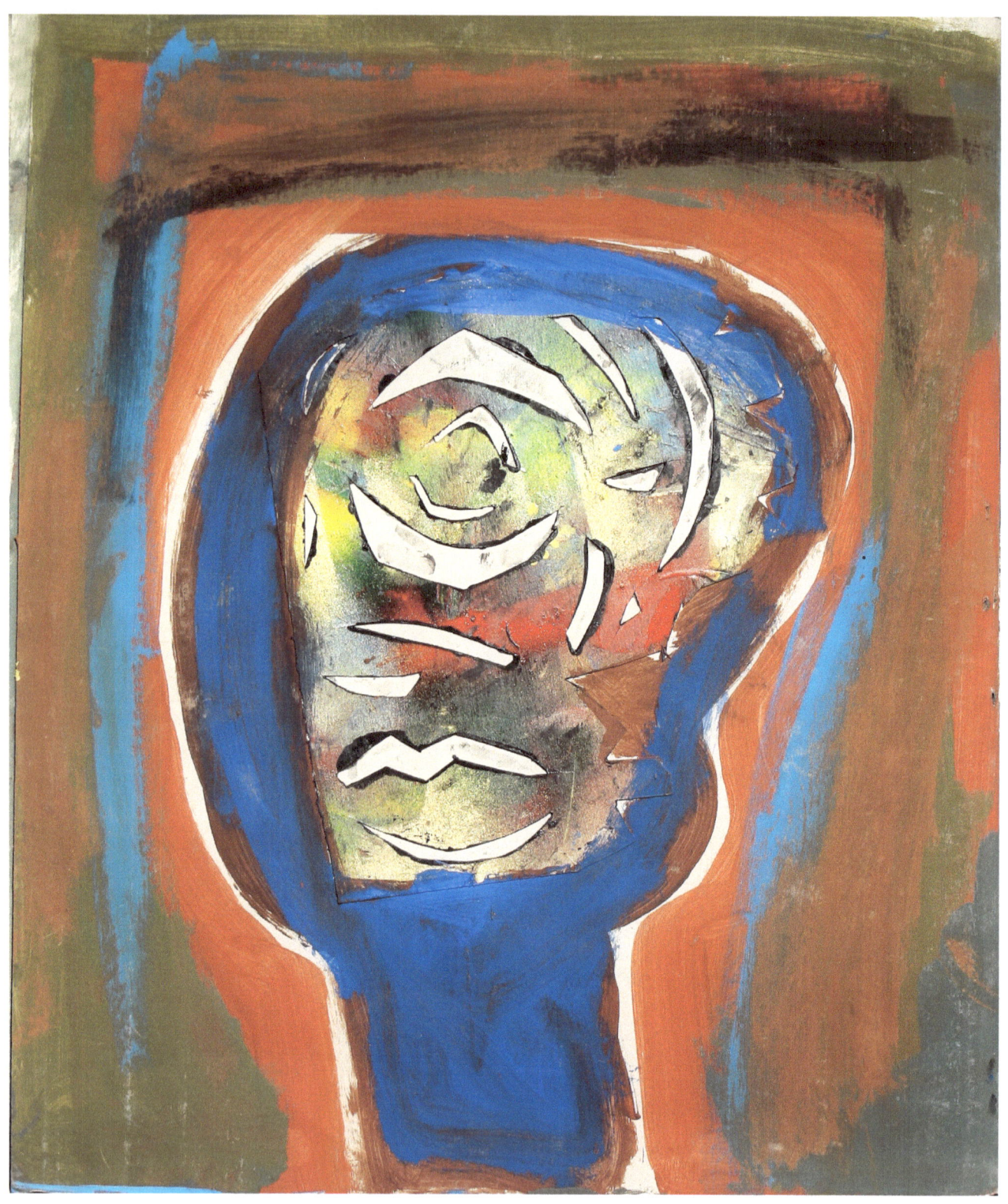

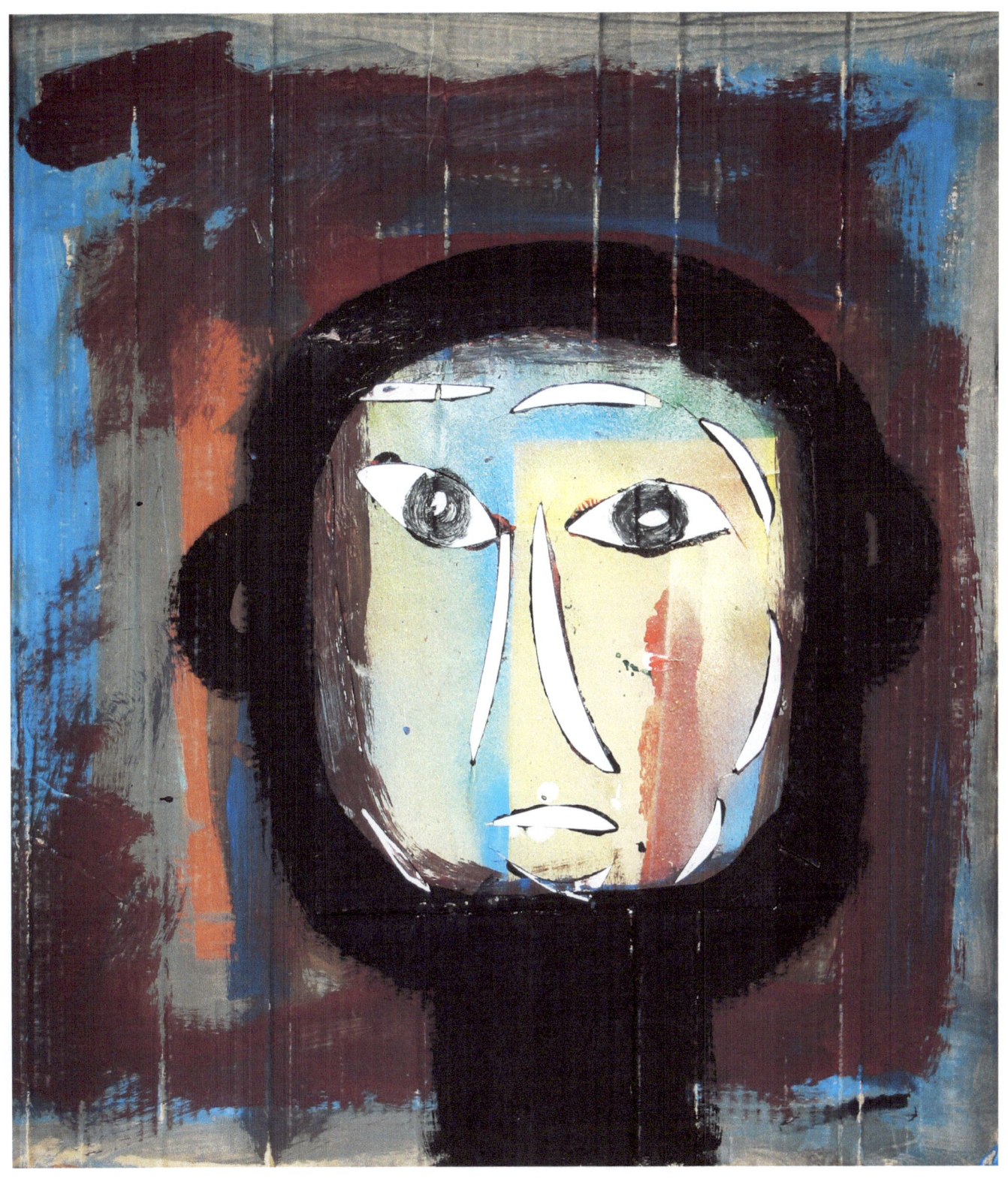

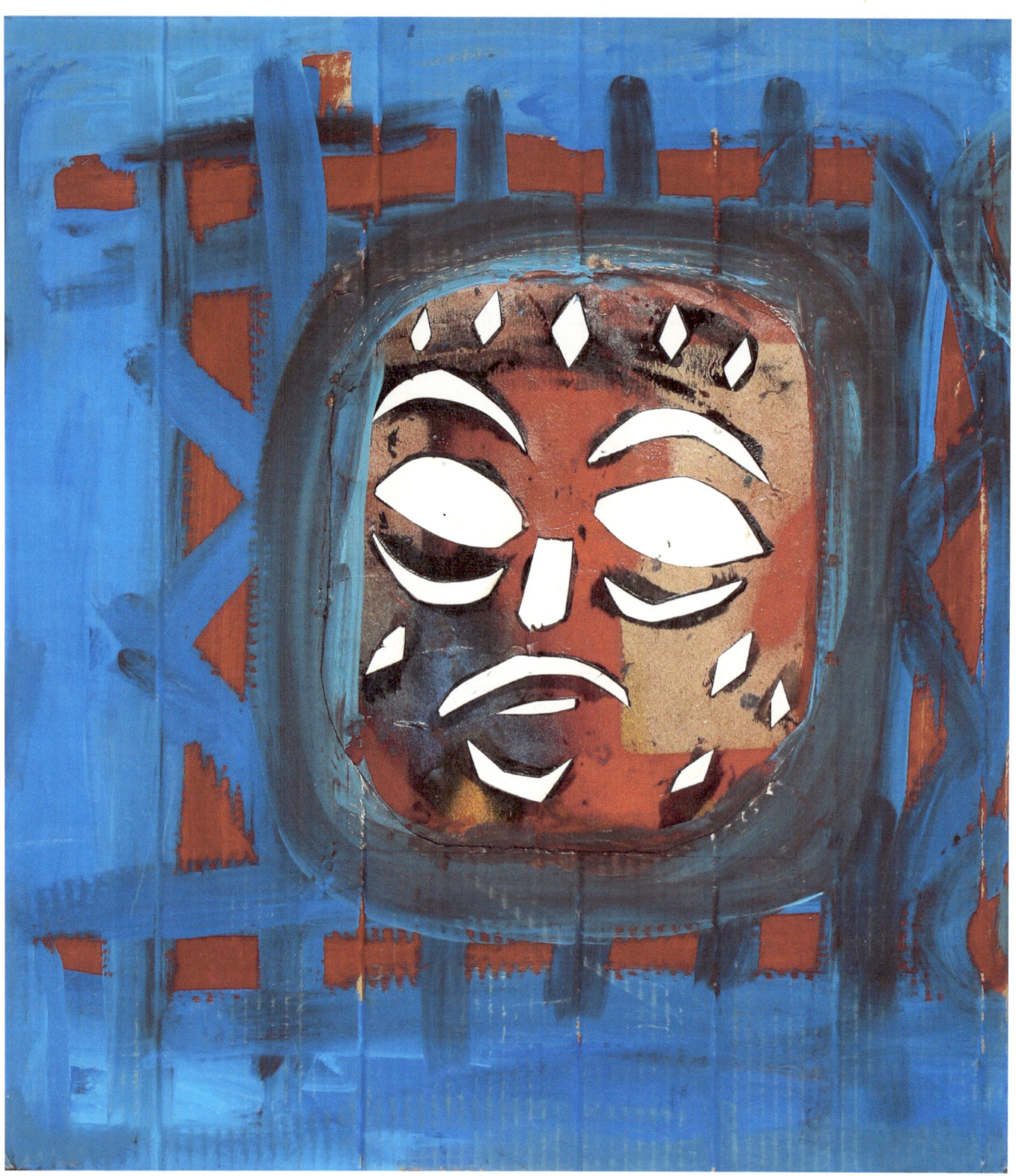

This publication is a reproduction of a unique book on cardboard made by Ibou Ndoye in 2011. Created with stencil cut-outs, acrylic and latex paints and drawing materials, it is one of several from that year's output that employs masks and identity as a common theme. The original size of the art book is 22.5" high by 19.5" wide.

In most African languages when they talk to you it's not direct. It's not like they're talking to you directly. Even if they look at you it's not like they look at you directly, like this. But here if you're talking to somebody and you don't look at him straight in the eyes, in this culture they say "Oh you lying."

But in Africa you talking to an old man and you look him straight in the eye it's disrespectful. You look at people straight in the eye they say "You look me like a fool."

You see that kind of cultural difference.

From Corey Andrew Powell & Jason Carey's 2012 documentary video,
Colors of a Native Son. Portrait of an Artist: Ibou Ndoye

My book arts are fun with a purpose. Most of them are made of recycled paper. The drawings are spontaneous. They are drawn directly and carelessly to the pages.

Drawing has always been part of my life. As a child growing up in Africa I always liked drawing with charcoal on walls, copy books, discarded boxes, newspapers and cardboards. Years later I have realized that what I used to play with as a child is called art.

When I work on a book I make believe that I am a child creating a toy to play with, or to share with others. That is the reason why my subject matter deals a lot with people's daily life, and imaginary faces of people I have met or I want to meet in real life or in my dreams.

I do not like either sketching or erasing images that I illustrate in my books, because my concept is that the first lines are always the most original and amazing ones. They are just like the first words from a child's mouth. They always bring joy to the artist.

Ibou Ndoye
Jersey City, 2012

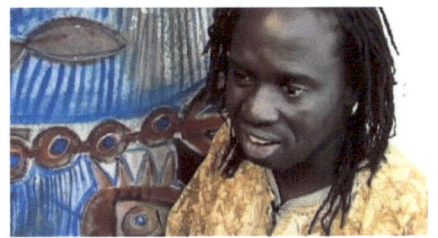

Ibou Ndoye blends his West African culture with his immersion in urban life in the NYC/Jersey City area to produce art and narratives that are both relevant and rooted in his strong sense of artistic and social heritage. Born in Dakar, Senegal, he became active as an artist there in the 1980s painting murals and making paintings on glass as part of the Set Setal movement.. Moving to the US in 2001, he continues to be an active presence, sharing his talent through exhibitions, workshops and classes in a wide variety of institutions including schools, museums, adult day care centers, homeless shelters and libraries from Brooklyn to Philadelphia.

NEW DRAWING

presents series of innovative, current images
from artists whose work explores and expands
the visual and conceptual language of drawing.

Other books in the Series include:
Jill Scipione: Skullnotebook
Carl Vierow: Detective at Red Castle Pier and Other Drawings
James Pustorino: Universechild
Hector G Romero: Last Coast Blues

Victory Hall Press

is a division of Victory Hall Inc., a
not-for-profit arts organization
producing exhibitions, events,
education programs, public
projects and publications, based
in the NJ/NY metro area.
Visit our website at
www.victoryhallpress.org
contact us at
victoryhall1@msn.com

www.ingramcontent.com/pod-product-compliance
Lightning Source LLC
Chambersburg PA
CBHW051101180526
45172CB00002B/732